2003

University of St. Francis Library

W9-AEP-482

DONALD LIPSKI: A BRIEF HISTORY OF TWINE

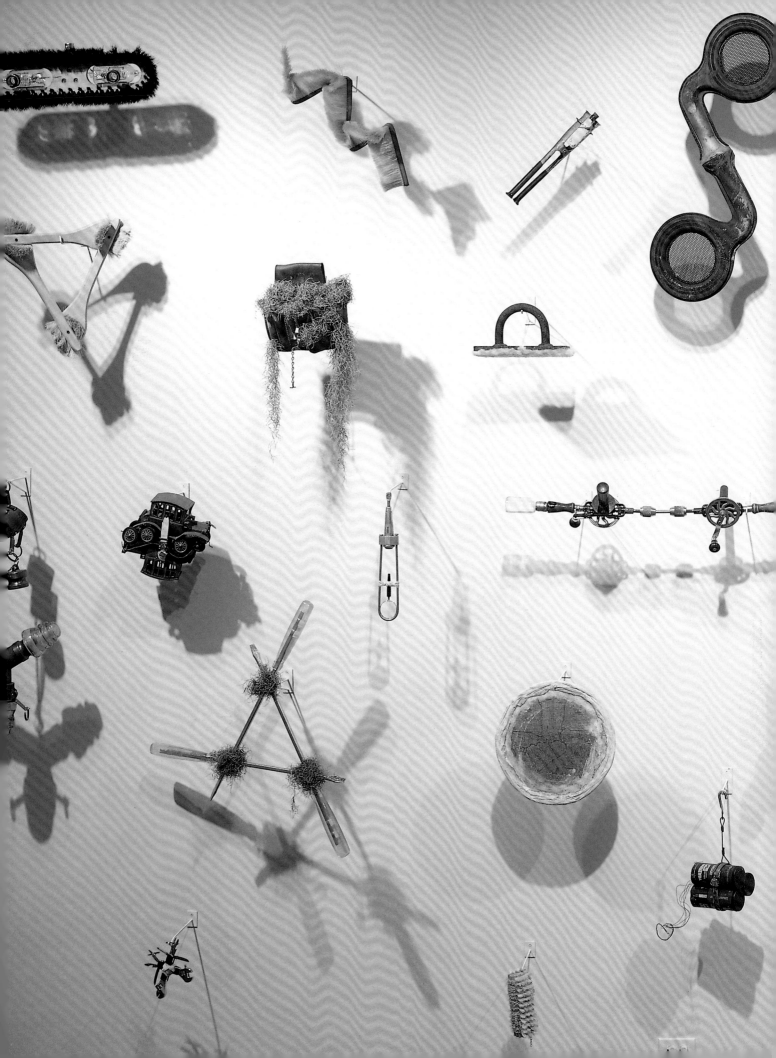

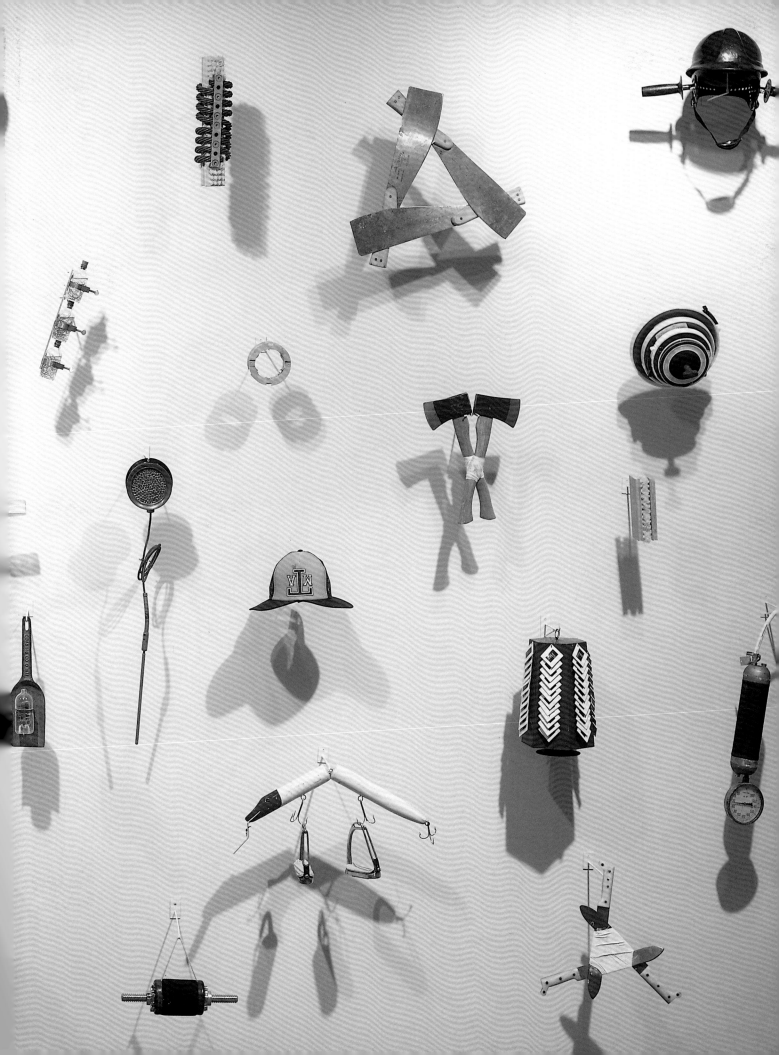

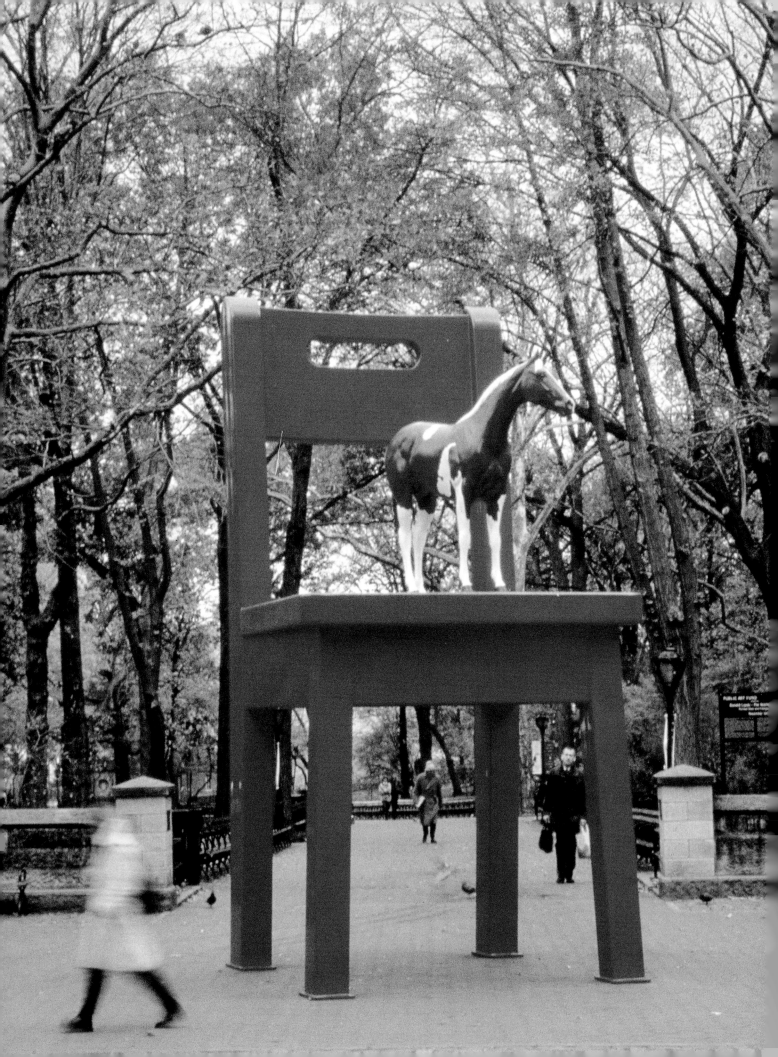

DONALD LIPSKI

A Brief History of Twine

Organized by Stephen Fleischman Madison Art Center Essay by Terrie Sultan

LIBRARY
...ERSITY OF ST. FRANCIS
JOLIET, ILLINOIS

This volume was published in conjunction with the exhibition, *Donald Lipski: A Brief History of Twine,* organized by the Madison Art Center, Wisconsin. The project was developed and presented as part of the Norman Bassett Foundation Exhibit Series. Major funding also has been provided by the National Endowment for the Arts; a grant from the Dane County Cultural Affairs Commission with additional funds from the Madison Community Foundation and the Overture Foundation; a grant from the Madison CitiARTS Commission, with additional funds from the Wisconsin Arts Board; J.H. Findorff & Son Inc.; Hausmann Insurance; the Terry Family Foundation; Jan Marshall Fox and Don Bednarek; The Verdin Company; The Art League of the Madison Art Center; the Exhibition Initiative Fund; The Madison Art Center's 2000–2001 Sustaining Benefactors; and a grant from the Wisconsin Arts Board with funds from the State of Wisconsin.

Exhibition Itinerary

Madison Art Center, Madison, Wisconsin
September 10 – November 12, 2000

Blaffer Gallery, The Art Museum of the University of Houston, Texas
January 12 – March 25, 2001

Library of Congress
Cataloging-in-Publication Data

Lipski, Donald, 1947–
 Donald Lipski: a brief history of twine / organized by Stephen Fleischman; essay by Terrie Sultan.
 p. cm.
 Catalog of an exhibition held at the Madison Art Center, Madison, Wis., Sept. 10–Nov. 12, 2000, the Blaffer Gallery, Houston, Tex., Jan. 12–Mar. 25, 2001.
 Includes bibliographical references.
 ISBN 0-913883-28-X (hardcover)
 1. Lipski, Donald, 1947—Exhibitions.
I. Madison Art Center. II. Blaffer Gallery.
III. Title.

N6537.L57 A4 2000
709'.2—dc21

00-055417

Artwork copyright © Donald Lipski

"Triangulating Head and Hand and Heart: The Art of Donald Lipski" © Terrie Sultan

Excerpts from *Einstein's Dreams* © Alan Lightman, reproduced by special permission of Alan Lightman

Copyright © 2000 Madison Art Center
211 State Street, Madison, WI 53703

Printed and bound in England
Edition of 2000
All rights reserved

Available through
D.A.P./Distributed Art Publishers
155 Sixth Avenue, 2nd Floor
New York, New York 10013
T 212.627.1999
F 212.627.9484

Photography:
 Peter Aaron/Esto: p. 53, 54
 Will Brown: p. 28 (top)
 Carol Davis: p. 92
 Mark Goldberg: p. 16
 Chris Gomien: p. 85
 Bild Stefan Nilsson: p. 91 (bottom)
 Graydon Wood: p. 20
 Dorothy Zeidman: p. 23, 27 (top), 33, 34, 71

Designer: Glenn Suokko, Woodstock, Vermont
Editor: Mary Maher, Madison, Wisconsin
Printing: Balding + Mansell, Norfolk, England

Cover:
 Untitled #91-08, 1991
 cotton, wood
 39 x 55 x 36 inches
 Courtesy of the artist and Galerie Lelong

Frontispiece:
 Texas Instruments (detail), 1992
 mixed media
 168 x 240 inches
 Courtesy of the artist and Galerie Lelong

Page 4:
 The Yearling, 1992
 steel, fiberglass
 240 x 120 x 120 inches
 As installed by the Public Art Fund at the Doris Friedman Plaza, Scholar's Gate, southeast entrance to Central Park, New York, New York

Contents

709.2
L767

$34.95

B&N

3-3-03

In the fall of 1969, my last year at the University of Wisconsin, I lied to get into a ceramics class. I said I had taken the prerequisites, drawing, design, and so forth. In reality, the only art course I had taken was beginning sculpture, which I flunked. The ceramics course was taught by Don Reitz, an inspirational teacher with enormous energy and enthusiasm. Watching art materialize from mud right before my eyes was magic. During that year, I became an artist.

Don is a hero to me and I dedicate *A Brief History of Twine* to him.

— *Donald Lipski*

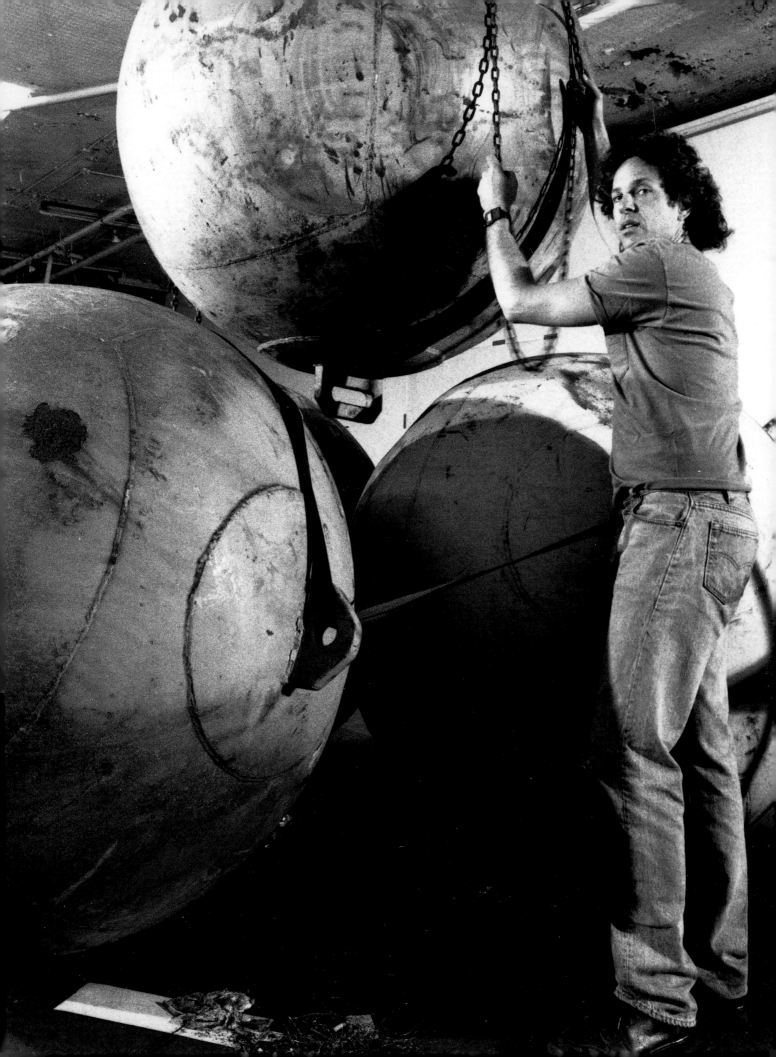

Donald Lipski: A Work in Process

Process is critical to Donald Lipski's sculpture. His work celebrates the object at the same time it reveals aspects of the human mind in operation. Likewise, Lipski is passionate about the hardware and everyday objects that populate his sculpture. His father's Chicago-based bicycle import business was an important force during his formative years and there are later, corresponding influences for his intellectual grounding. As a history student at the University of Wisconsin-Madison, he came to appreciate the nuances that context and the passage of time contribute to the perception of ordinary events and things.

It is difficult to see Lipski's work without pondering the relationships that exist between the objects he combines. These often ironic juxtapositions are key elements in the aesthetic and intellectual order of his compositions. The hallmarks of Lipski's sculpture, inventive combinations of existing objects, also tend to obscure the more process-oriented side of his oeuvre.

Editing—that is, selecting a subject and honing an approach—is a basic component of any artwork. Decisions about how and what to paint, photograph or videotape are critical in shaping a work. Viewers normally are content to accept the artist-defined boundaries of a finished work, only rarely do they reflect on what else might exist. In Lipski's work, the editing process is almost visceral. Why combine taper candles with a baby crib or a glass handle with a tool for digging and chopping? Lipski's mind, as it sifts the possibilities, becomes a palpable force and for every connection the artist makes between objects, it is easy to envision the dozens never offered as possibilities. Lipski's sculpture is an open-ended portrait of the mind at work.

Pieces of String Too Short to Save approaches the idea of editing from a different perspective. Originally installed in the Brooklyn Museum of Art Grand Lobby in 1993, the installation consisted of everything that was in Lipski's soon-to-be-vacated studio at the time of

the exhibition. On the surface, it suggests an artwork that appears unedited. The result calls attention to the way the mind makes choices or, in this case, abdicates its normal role.

The "compulsive thought" also plays a central role in Lipski's artmaking. A block of wood "carved" by the repetitive action of throwing a knife, a table methodically wrapped with string, a swirling installation of thousands of double-edged razor blades stuck into walls all represent important elements in Lipski's body of work over the past few decades. These sculptural forms provide a direct connection to brain impulses, albeit slightly dysfunctional ones. The mechanics of the thought itself is memorialized in Lipski's sculpture. His work presents a complex moving target rather than a fixed point of arrival.

This does not imply that the finished object is an after-thought for Lipski. Aesthetic considerations are paramount in his work. He is a devoted craftsman with a strong appreciation for detail and precision. In *The Humidors,* Lipski compensates for the natural taper of the cigarettes to create carefully aligned rows. On other occasions, Lipski employs highly skilled craftsmen to help him realize a piece or series. Jonquil LeMaster produced Lipski's recent *Exquisite Copse* series, which uses synthetic materials to achieve a *tromp l'oeil* wood effect replete with natural wood grain. It is magical when the logs bend and twist in a seemingly impossible fashion.

In Lipski's skilled hands, ordinary fly swatters and ballet shoes become poetic centerpieces of sculpture. Similarly, everyday thought processes—like editing, ordering, and compulsivity—are elevated to a heroic level. The marriage of object and intellect offer dimensionality and richness to an evolving body of work.

This exhibition continues the Madison Art Center's tradition of organizing and premiering mid-career surveys of work by noted artists. After its Madison presentation, *Donald Lipski: A Brief History of Twine* travels to the Blaffer Gallery, The Art Museum of the University of Houston.

It has been a pleasure to collaborate with Donald Lipski on every aspect of *A Brief History of Twine.* Above all, his generous spirit and sense of humor made organizing the exhibition and producing the catalogue a rewarding experience.

My deepest thanks also go to Mary Sabbatino, Director of Galerie Lelong in New York, and her staff who answered numerous questions and greatly assisted with many aspects of the project. The Rhona Hoffman Gallery in Chicago, Carl Solway Gallery in Cincinnati, and the Hill Gallery in Birmingham, Michigan, also provided invaluable help.

Several generous funders helped make *Donald Lipski: A Brief History of Twine* possible. The project was developed and presented as part of the Norman Bassett Foundation Exhibit Series. Major funding also has been provided by the National Endowment for the Arts; a grant from the Dane County Cultural Affairs Commission with additional funds from the Madison Community Foundation and the Overture Foundation; a grant from the Madison CitiARTS Commission, with additional funds from the Wisconsin Arts Board; J. H. Findorff & Son Inc.; Hausmann Insurance; the Terry

Family Foundation; Jan Marshall Fox and Don Bednarek; The Verdin Company; The Art League of the Madison Art Center; the Exhibition Initiative Fund; The Madison Art Center's 2000–2001 Sustaining Benefactors; and a grant from the Wisconsin Arts Board with funds from the State of Wisconsin.

Terrie Sultan, Director of the Blaffer Gallery, The Art Museum of the University of Houston, authored a thoughtful essay tracing the evolution of Lipski's career. Alan Lightman graciously agreed to the use of excerpts from his noted novel, *Einstein's Dreams*. Glenn Suokko designed this elegant volume, the text of which was insightfully edited by Mary Maher.

The exhibition was made possible by the generosity of the lenders who agreed to make their works available. I am grateful to Gayle and Andrew Camden; Dudley and Michael Del Balso; The Detroit Institute of Arts; Galerie Lelong; Hill Gallery; Rhona Hoffman Gallery; Terri Hyland; Jackson Hyland-Lipski; LaGuardia High School of Music & Art and Performing Arts; Laumeier Sculpture Park and Museum; Donald Lipski; Museum of Contemporary Art, San Diego; Patsy R. and Raymond D. Nasher; New York City Board of Education; Reva and Philip Shovers; Carl Solway Gallery; The Verdin Company; Frederick R. Weisman Art Museum, University of Minnesota; the West Family; and Janis and William Wetsman.

I thank the Madison Art Center's Board of Trustees for their terrific ongoing support. My appreciation goes to the entire Madison Art Center staff whose efforts were essential to the organization of this project. I am grateful to Jennifer Lin, Assistant to the Director/ Publications Specialist, who contributed immeasurably to this exhibition and catalogue. Several other staff members deserve special recognition: Marilyn Sohi, Registrar; Sheri Castelnuovo, Curator of Education; Sara Krajewski, Curator of Exhibitions; Jill Shaw, Curatorial Assistant; Michael Grant, Director of Public Information; and Technical Services Supervisor Mark Verstegen and his entire installation crew.

Stephen Fleischman
Director
Madison Art Center

The Starry Night (detail), 1994
steel, installation view at the Capp Street
Project, San Francisco, California

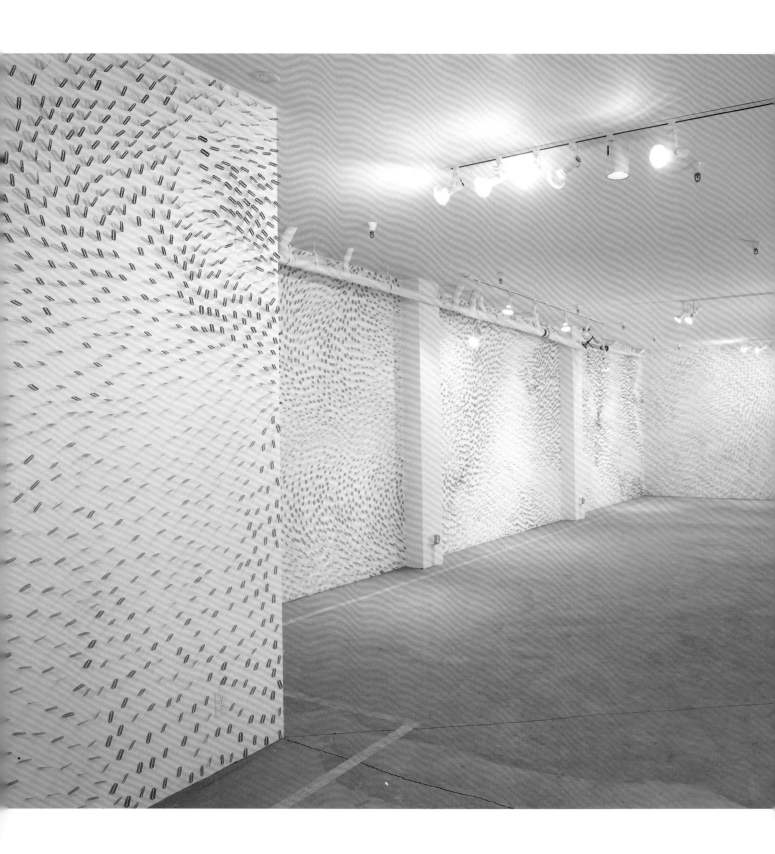

Triangulating Head and Hand and Heart: The Art of Donald Lipski

Terrie Sultan

For in this world, time has three dimensions, like space. Just as an object may move in three perpendicular directions, corresponding to horizontal, vertical, and longitudinal, so an object may participate in three perpendicular futures.

Einstein's Dreams[1]

Donald Lipski is a romantic idealist, an optimist. He would have to be, to continually discover so much aesthetic pleasure in materials that are both protean and prosaic. How else to explain an artist who can make a room-sized installation from old-fashioned, double-edged, disposable razor blades and call it *The Starry Night?* Or fathom how the artist's meaning resonates *visually* so that the viewer entering the gallery quite literally "gets the point" and, in so doing, recognizes the intangible beauty of such a compulsive enterprise? Lipski's prodigious brand of art making is grounded in free association. "My normal way of working is that I have these things and I put them together and, if they look right, I attach them," Lipski said recently. "I have

no patience and that is, in a sense, what led me to making things out of things instead of something more laborious. It is very immediate."[2]

In its immediacy, Lipski's combinative art poses suggestive questions. The physical objects that find their way into his production are the quotidian stuff of life, made metaphorical. His work is the art both of denial and of renewal. Capable of subverting the practical functionality and replicated sameness of mass-produced objects, his surprising combinations invite us to reconsider our assumptions about the commonplace. Lipski doesn't load his objects with conscious meaning, but he readily acknowledges his assemblages and amalgams of seemingly incompatible materials can connect with something deep in our psyches. What Lipski really seems preoccupied with—despite an insistent materiality—is the nature of time. As in *Einstein's Dreams*, writer Alan Lightman's poetic rumination on the

physics of space, Lipski views time as a peculiarly malleable and therefore natural sculptural ingredient. It can be circular or flow backwards, slow down or even come to a halt. Thinking about how Lipski's art exemplifies different types of time, one is struck by his ability to create settings where the relative time of infinite possibilities and physical time, with its inexorable march forward, readily coexist.

Lipski was born in Chicago in 1947. His father, a bicycle wholesaler, was the first post-war importer of bicycle parts from Japan. Lipski remembers time spent working in his father's business, surrounded by shipping pallets piled high with parts. "My father didn't have a factory because everything was jobbed out," he recalls. "He did design some accessories. It was his idea to take an electric horn and an electric light and put them together into one unit." Lipski notes that in later years, his Brooklyn studio conjured up the smell of his father's warehouse.

Lipski's mother was a stay-at-home mom whose creativity in the kitchen was endlessly entertaining to the young future artist. "I used to sit with her and watch her in the kitchen," he says. "She was a good cook and a great baker who went all out for parties. I remember, she made very elaborate-looking things, like pineapples out of chopped liver and cakes in the shape of logs." In this upper middle-class family, Lipski was the child who always made things—building with tinkertoys and erector sets, carving in wood. His father taught him magic tricks, something Lipski loved because "it empowers a young boy to be able to fool people and take center stage."[3] As a young amateur magician, he constructed

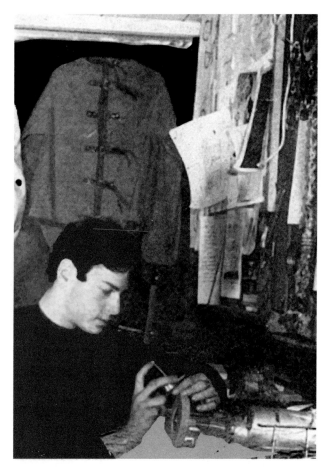

Donald Lipski, 1964,
creating escape artist "gimmick"
in basement workshop

his own tricks and escapes. One summer, he and a friend apprenticed themselves to a locksmith. For Lipski, magic was his first experience in the possibilities of alchemic transformation.

Getting Started

In this world, there are two times. There is mechanical time and there is body time. The first is as rigid and metallic as a massive pendulum or iron that swings back and forth, back and forth, back and forth. The second squirms and wriggles like a bluefish in a bay. The first is unyielding, predetermined. The second makes up its mind as it goes along.

Einstein's Dreams[4]

Lipski majored in history at the University of Wisconsin-Madison. In the late 1960s, at a campus dominated by student political activism and personal experimentation, Lipski found himself in an American Studies course which had been "taken over by some Trotskyites...you could stretch the point of history or write a paragraph explaining why French existentialism was relevant to American culture." It was a freewheeling environment that invited forays into art, philosophy, science, or anything one wanted to explore. His knowledge of art then was limited to Andy Warhol, George Segal, Constantine Brancusi, and Alberto Giacometti. His college roommate, the son of a collector, sparked Lipski's interest by showing him a watercolor by Edward Keinholz. *For $108* was a text-as-image watercolor painting of the words "For $108," which was the title, subject matter, and price of the work. This fascinated Lipski. "It kindled my interest in contemporary art and, I would say, in the years after that, conceptual art."

In his senior year, with much of his course work completed and time on his hands, Lipski took classes in woodworking and ceramics, a decision that quickly and irrevocably propelled him into the world of artisans and artists. Don Reitz, his ceramics instructor, was an especially influential role model. Following a peripatetic six months in Europe to investigate the possibility of an apprenticeship in furniture making, he opted for graduate school, first at the University of Colorado at Boulder and then the Cranbrook Academy of Art outside Detroit. While at Cranbrook, Lipski continued his desultory pursuit of ceramics, but found his real inspiration lay elsewhere, especially in the complexities that unfolded during the critiques he attended in other departments. Interactive, volatile, and theoretical, these gab sessions were—for the developing artist—inspiring, confusing, and challenging. "I was very outspoken at all these crits, because I knew nothing," Lipski recollects. "I didn't even understand the vocabulary. If they would say 'plastic' I would say, 'I don't know what you mean by plastic.' Plastic, elasticity, you know. So I would say 'you are all bullshitting.' Which of course they weren't, they were just trying to find words to describe things." Lipski began to find his place among these people who were making art and thinking seriously about it. He started spending time in the photography department and making sculpture.

After receiving his MFA from Cranbrook in 1973, Lipski taught at the University of Oklahoma. While there, he was invited to participate in a show at the Wichita Art Museum. His installation, which he called somewhat tongue in cheek, *Gathering Dust,* consisted

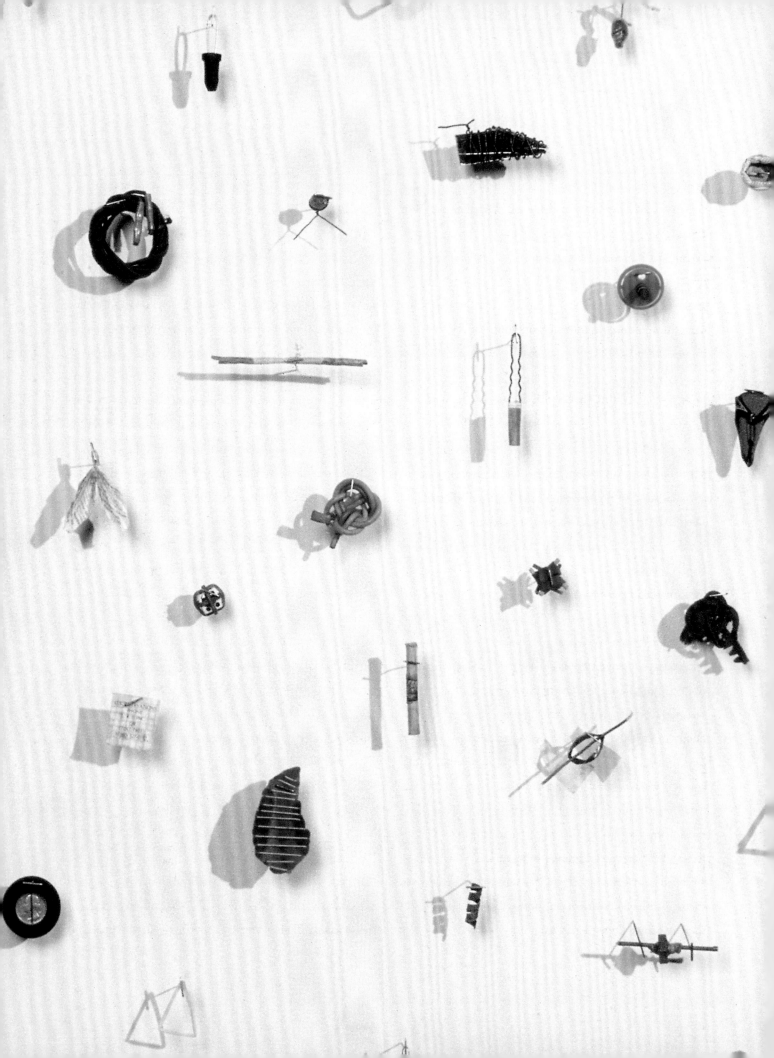

of 100 or so tiny sculptures, assembled and reconfigured from matchbooks, bits and pieces of twigs or other woven, wrapped, or manipulated detritus. Like specimens in an invented natural science museum, the arrangement of these simple, often obsessive gestures, pinned to the wall, elevated what were essentially three-dimensional doodles into a compelling encyclopedia of aesthetically suggestive sculptures. The possibilities of *Gathering Dust* captivated Lipski and he began to reconfigure its elements in differing combinations and patterns, creating a book of the photographed objects categorized in terms of shape, material, and color, or aligning a year's worth of the sculptures arranged on the wall in chronological order. For Lipski, *Gathering Dust* was a watershed, but it also was an extension of the things he had done all his life: practicing a personal sleight of hand that sought to transform base materials into objects of wonder.

Inspect any square-foot detail of *Gathering Dust* and Lipski's expansive visual vocabulary is revealed. Each small object exists as an individual entity with its own personality. Take the genus matchbooks (woven into mats and baskets or propped up like minute candelabra); paperclips (twisted into triangles and bent into anthropomorphic poses); or safety pins (bound in bits of colored cloth). Each tiny scrap proposes an intuitive, time-based, and associative activity for the viewer, a reordering that inverts both the original use of the object and the primary function of its making. Those possibilities also diverted Lipski's attention as he worked through the basics of what it meant to be an artist. "In the *Gathering Dust* pieces, each little sculpture is a very

pure hunk of time . . . because when I am making something I am so focused that it is like the whole universe to me," he explains. "If there is anything I strive for as an artist, it is not so much what I communicate to anybody else, but that sort of rapture I achieve when I am fully engaged in making whatever it is. Those are the moments when time stands still." The objects of *Gathering Dust* vividly recall the experimental, subversive atmosphere of Bruce Nauman's studio videos from the late 1960s and early 1970s, such as *Bouncing in a Corner* or *Pacing in the Studio*. Nauman was a strong influence on Lipski, who says, "[Nauman] seemed so clear about not having any idea about what he was doing. It was as if he was thinking 'Here I am in the studio in Pasadena, and I don't know what I am supposed to be doing. So one day I find myself bouncing balls, turn on the video camera and film myself bouncing balls.'" Like those videos, which Nauman made to document a transition between one artistic approach and another, *Gathering Dust* grew from inconsequential beginnings to set the tone for Lipski's substantial growth and development as an artist over the next decade.

Passing Time and Building Steam

In this world, the passage of time brings increasing order. Order is the law of nature, the universal trend, the cosmic direction. If time is an arrow, that arrow points toward order. The future is pattern, organization, union, intensification; the past, randomness, confusion, disintegration, dissipation.

Einstein's Dreams[5]

Gathering Dust was followed quickly by two other series, *Passing Time* and *Building Steam*. If the ephem-

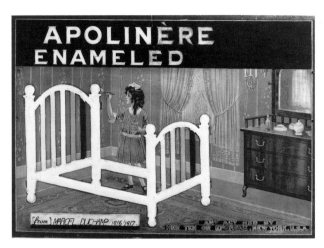

Marcel Duchamp, *Apolinère Enameled*, 1916–17, painted tin advertisment, 9¼ x 13¼ inches, Philadelphia Museum of Art: Louise and Walter Arensberg Collection, © 2000 Artist Rights Society (ARS), New York/ADAGP, Paris/Estate of Marcel Duchamp

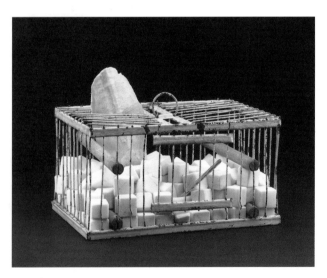

Marcel Duchamp, *Ready-Made, Why Not Sneeze Rrose Sélavy?*, 1921, marble blocks in shape of lump sugar, thermometer, wood, cuttlebone on bone cage, 4½ x 8⅝ x 6⅜ inches, Philadelphia Museum of Art: Louise and Walter Arensberg Collection, © 2000 Artist Rights Society (ARS), New York/ADAGP, Paris/Estate of Marcel Duchamp

eral objects that constituted *Gathering Dust* reflect Lipski's reliance on free-form combinations and a stream-of-consciousness process that coalesce only at the last minute into a group identity, the sculptures that followed—while still combinative—are rooted as singular objects in the physical world. In these pieces, Lipski's odd objects increasingly suggest Marcel Duchamp's idiosyncratic, ironic, altered, or assisted ready-mades, such as *Apolinère Enameled* (1916–17) or *Why Not Sneeze Rrose Sélavy?* (1921). Lipski's approach, however, is more romantic and ideologically nonaligned. Unlike Duchamp's iconoclastic and purposefully hermeneutic stratagems, Lipski does not seek to break down the established hierarchies of painting and sculpture or forge an ironic distance between art and life. Rather, his impetus is to create enigmatic assemblages that suggest the intersection between rational thought, memory, and intuition.

Each object made under the rubric *Passing Time* signifies the fundamentals of repetitive motion that, by sheer dint of will, advances an action through time. *Passing Time No. 225* (1980–81) (p. 91) shows the result of the artist's repeated flinging of a knife into a painted wood target, a pastime Lipski seized upon as "woodcarving from twenty feet."[6] In *Passing Time No. 96* (1980–81), a paintbrush handle is entirely covered with individually affixed grains of brown rice, as if each grain marked both the passing of time and the artist's laborious attempt to document it. If one assumes Lipski's numbering sequence establishes a lineage within this series, he must have spent a lot of time *kanoodling* with the elements stockpiled in his studio.

As he recounted to Jan Reilly in a 1991 interview, "I thought of the words—passing time—in two ways that carried equal weight. One was that I was keeping busy, that I was 'passing time' making it. The other, though, is about passing time like you would..." Reilly: "Pass the baton?" Lipski: "Exactly."[7]

Lipski's *Building Steam* title is a punning play on words that also contains a powerful metaphorical allusion. "Steam is invisible," the artist explains. "It is that area between the steam kettle and vapor. What I do is I build. I'm a builder, and what I build is like steam."[8] Lipski's title also communicates the essential dilemma of his *bricoleur* or do-it-yourself approach. Can anything concrete be built out of steam? If so, can one call it art? In *Building Steam*, Lipski begins to formulate themes that would recur throughout the 1980s and 1990s. Some are compositional motifs—like circles, grids, and other basic geometric forms—that organize into a plethora of seemingly incongruent materials. Favorite objects come to the fore to complement these formal typologies: books and candles; saws and other implements of work. In this sense he builds on the groundwork laid by the dadaists and surrealists, who embraced the everyday, cast-off, or degraded as the truest exemplar of the unconscious. More importantly, Lipski begins to formulate content to match his material prowess. While it is tempting to categorize Lipski's object-making as modern-day surrealism, he does not acknowledge any real affinity with the surrealists and emphatically denies attempts to layer his work with networks of psychoanalytical associations, archetypal, or dream-based imagery. In his own words, "My art is

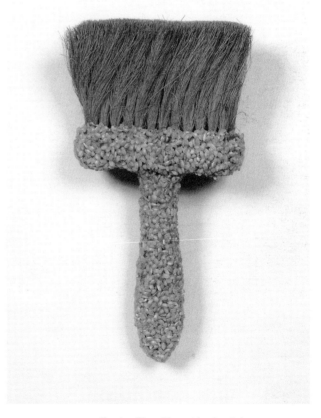

Passing Time No. 96 (1980–81),
wood, natural bristle, rice, 9 x 5 ¹/₂ x 2 inches,
Collection of the artist

very much based in reality. It deals with things, and pretty mundane things at that, in the sense that it is very corporeal and tangible. I am much more of a realist than a surrealist."

Emotional resonance and psychological associations are abundantly evident in Lipski's sculpture, but the beauty of his work stems from its refusal, with certain notable exceptions, to define or plot the viewers' course precisely. His oddly configured object groups resonate with multiple, overlapping tones, much the way a tuning fork creates a ringing harmonic when struck. Books, for example, have long played a central role in Lipski's work. Books are tools, in a sense, and it is in his nature to be attracted to them in much the same way he is drawn to saws and hammers, bolts and screws, steel wool, and industrial glass tubing. This tension between the hand and the intellect is evident in *Building Steam #105* (1983) (p. 65), which conflates the traditional value of books as revered objects of learning with their more prosaic, mass-produced reality. Bolting an industrial handle to a two-page spread that charts the opposites of the North and South polar constellations, Lipski draws our attention to the paradox of knowledge in the late-20th century: the impetus to possess editions of important works of literature and science as symbols of social status and erudition at the expense or ignorance of the content within. Sandwiching molten glass between the covers of a payroll and time ledger or strapping together a tower of books, Lipski restates this theme in *Pilchuck #90–14* (1990) (p. 69) and *Untitled #91–001* (1991) (p. 76). The knowledge contained in each book becomes remote and mute

once the book is transformed into a sculptural object. Manipulating the manipulators, he robs them of their assigned tasks and meanings and opens them to reclassification.

Broken Wings

Consider a world in which cause and effect are erratic. Sometimes the first precedes the second, sometimes the second the first. Or perhaps cause lies forever in the past while effect in the future, but future and past are entwined....

...In this world, artists are joyous. Unpredictability is the life of their paintings, their music, their novels. They delight in events not forecasted, happenings without explanation, retrospective.

Einstein's Dreams[9]

A restless omnivore, Lipski constantly seeks avenues to broaden the scope and scale of his sculptural materials. His habit of fetishising or altering found objects or the detritus of everyday life meant that, over time, Lipski acquired vast quantities of marked down and cast-off goods from warehouse sales. In 1986, the Hillwood Art Gallery at Long Island University invited him to collaborate on an exhibition with one of the most important local industries, the Grumman Aerospace Corporation. Although Lipski had worked with industrial materials in the past, the possibilities presented by Grumman's massive scrap yard forced him to rethink his scavenger's sensibility. On a personal level, the heroic scale and predominately masculine nature of these machine parts and their association with war affected him viscerally. Unlike the "stuff" of the street or thrift shop gathered at random, or even bulk or odd-

lot purchases, access to Grumman's enormous array of highly technological, exceptionally well-made products presented Lipski with an opportunity to present different approaches and themes in his sculpture. His interaction with Grumman also introduced him to the people who manufactured these exemplars of national defense. For the first time, Lipski abandoned the insular and hermetic routine of the studio artist to learn from, work with and, in some cases, negotiate directly with others—in this case, the management and labor of Grumman's Long Island factory—who could have a significant impact on the exhibition's outcome.

Lipski's original idea was to create the exhibition entirely from Grumman objects found in the scrap yard, but he could not acquire what he truly wanted: the Plexiglas canopies of airplane cockpits and other large-scale components immediately recognizable as military equipment. Politically aware if not overtly activist, Lipski wanted to confront his own ambivalent feelings about collaborating with the same military industrial complex that was such a potent target of protest in his student years. This caused something of a creative impasse until the artist acknowledged he could augment the Grumman materials by incorporating things gathered from other sources—thereby maintaining "truth to materials" as an indispensable ideal. Lipski's ideal is apparent in the hauntingly elegiac *Broken Wings #23* (1986), composed of two airplane wing sections nestled like jewels on a bed of shattered glass or the more enigmatic melange of *Broken Wings #3* (1986) (p. 92), with its pod housing jutting out from the wall that bristles with household buckets, periscopes, and other miscel-

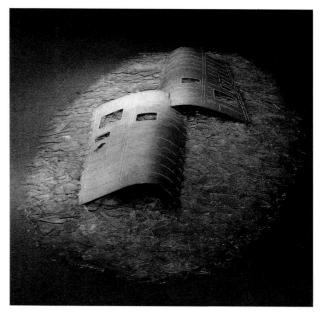

Broken Wings #23, 1986, aluminum, glass, cotton, 20 x 95 x 185 inches, Collection of the artist

laneous hardware. By expanding the boundaries of his artistic criteria, Lipski truly found his public voice. *Broken Wings* moves away from the rarified realm of the art object and toward a more direct, proactive, and subversive engagement with the real world.

Dominion and Display

In this world, time is like a flow of water, occasionally displaced by a bit of debris, a passing breeze. Now and then, some cosmic disturbance will cause a rivulet of time to turn away from the mainstream, to make connection backstream.

Einstein's Dreams[10]

As a national emblem and a "lightening rod for a whole range of emotions and attitudes"[11] about our "land of the free and home of the brave,"[12] the American flag has long functioned as a powerful icon in American art. From Childe Hassam's celebratory World War I paintings and Jasper John's seminal series of the mid- to late-1950s to works by conceptual artists like May Stevens and David Hammons (p. 26), the red, white, and blue has been adopted and exploited as a defining symbol of American identity. Lipski doesn't regard himself as an iconoclast, but he knows good material when he sees it. "I make my work out of anything in the world," he explains. "That someone would pass a law saying, 'OK, you can make your work out of anything in the world, except this one item,' it becomes like the apple in the Garden of Eden. I never was a well-behaved kid when it came to rules that struck me as arbitrary and useless."[13]

When Congress proposed a Constitutional amendment against flag desecration in 1989, Lipski felt compelled to respond. He notes, "We have grown up with

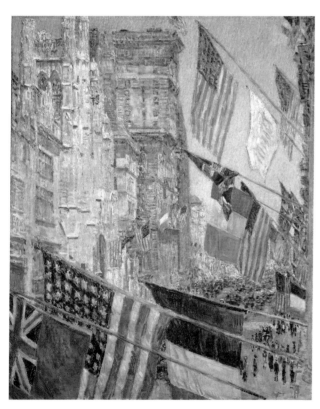

Childe Hassam, *Allies Day, May 1917,*
oil on canvas, 36¹/₂ x 30¹/₄ inches,
Gift of Ethelyn McKinney in memory of
her brother, Glenn Ford McKinney,
Photograph © 2000 Board of Trustees,
National Gallery of Art, Washington

extraordinary freedoms and take them for granted. There is no guarantee that we are always going to have them, and those battles are constantly being fought."[14] Lipski first incorporated the American flag in *The Ether* (1986) (p. 27). This eerie coupling of a whitewashed flag and an operating room light came together, like many of his works, through the serendipity of random proximity in his studio. Predating the constitutional uproar, it was not intended to be a political statement, but an exploration of his anxiety about impending back surgery. The allegorical overtones of such a combination later came to seem politically relevant. As I observed when writing about Lipski's work in 1991, "...the artist's anxieties, projected through *The Ether*, take on a different tone; the cyclopean operating room light, draped, politician-like, in the cloak of a whitewashed American flag, assumes the character of the all-seeing eye of Big Brother, which sees without depth or perspective."[15] After Texas outlawed flag burning, Lipski created his first pointed response to the political debate. *Half Conceals/Half Discloses* (1989) (p. 27) is a 16-by-8-foot flag patterned with an all-over grid of circle-shaped burns. From the overt association with defilement to the subtle evocation of the second verse of the Star Spangled Banner, *Half Conceals/Half Discloses* is a loving rendition of the battlefield origins of our flag.[16] Congress' continued preoccupation with flag burning underscored a rising wave of political conservatism that quickly developed into a cultural battle about the nature and purpose of federal funding for the arts. Politicians who previously ignored the arts, rose to their feet to denounce the National Endowment for

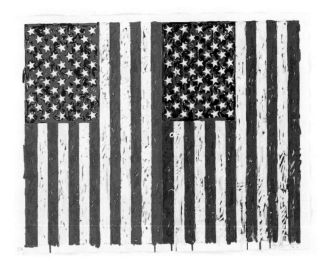

Jasper Johns, *Flags I,* 1973, screenprint on paper, 27³/₈ x 35¹/₂ inches, Collection of Walker Art Center, Gift of Judy and Kenneth Dayton, 1988, © Jasper Johns and Simca Print Artists, Inc./Licensed by VAGA, New York, New York

LIBRARY
VERSITY OF ST. FRANCIS
JOLIET, ILLINOIS

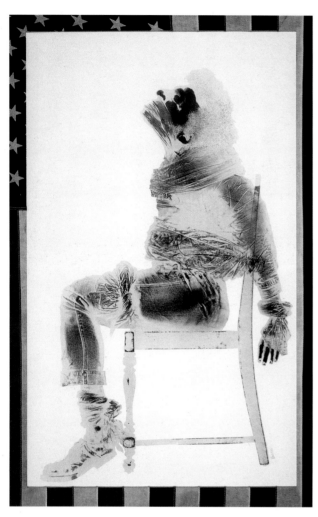

David Hammons, *Injustice Case*, 1970,
mixed media print, 63 x 40¹/₂ inches,
Collection of Los Angeles County Museum
of Art, Museum Purchase with M.A.
Aquisitions Fund, reproduced with special
permission of the artist

the Arts as liberal, elite, and out of touch with the general public. Notable among the critics were Representative Richard Armey of Texas (R) and his senatorial colleague, Alphonse D'Amato of New York (R). D'Amato led the charge on the floor of the Senate in May 1989 when he "ripped up a Serrano catalog, threw it on the floor, stomped on it, and then made a speech."[17] Lipski found himself in the center of the firestorm a month later when the Director of the Corcoran Gallery of Art cancelled an exhibition of photographs by Robert Mapplethorpe. Lipski was to participate in a group show I had been organizing for the Corcoran. The six artists involved jointly decided to withdraw to protest the Mapplethorpe cancellation.[18] A year later, Lipski, along with fellow protestor Buzz Spector, agreed to return to the Corcoran to develop a two-person exhibition on the theme of transgression.

Before that, in 1990, an invitation to work with the artisans of The Fabric Workshop in Philadelphia provided Lipski the wherewithal to range far and wide in exploring the flag as an artistic icon. Overseeing fabrication of his work rather than simply making it himself was a radical departure for an artist who prided himself on his skills of prestidigitation. Accustomed as he was to working with resolutely down-to-earth materials, Lipski found himself discussing degrees of translucency and subtleties of color, and learning the properties of silk organza, linen, and wool gabardine. Working with The Fabric Workshop's pattern makers, cutters, and sewers, he selected ready-made material, fabricated new bolts of cloth, and cut and sewed miles

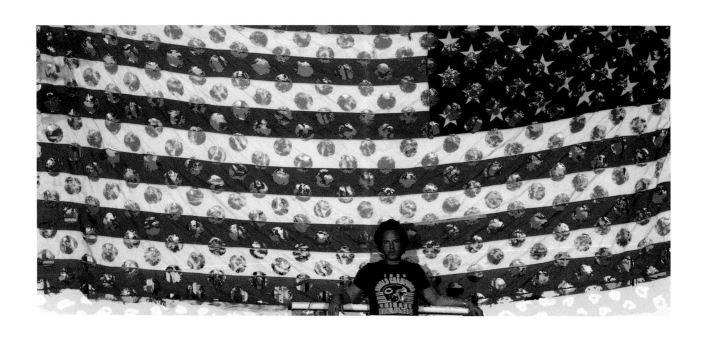

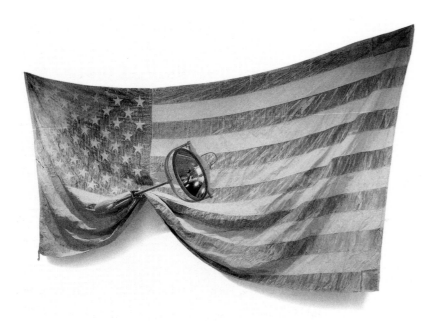

top:
Half Conceals, Half Discloses, 1989, nylon,
196 x 90 inches, Collection of the artist

The Ether, 1986, mixed media,
108 x 200 x 33 inches, Collection of
Robert J. Shiffler

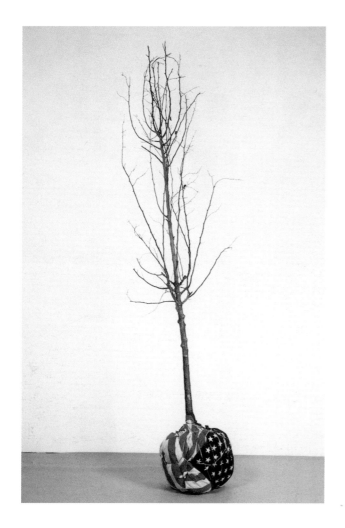

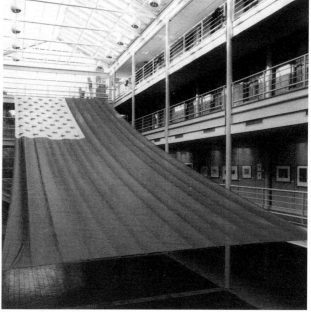

Who's Afraid of Red, White & Blue? #30,
1990, pear tree, cotton, 132 x 36 x 36 inches,
Collection of the artist

right:
Who's Afraid of Red, White & Blue? #31,
1990, nylon, 840 x 288 inches, installation at
the Haviland Building of the University of the
Arts, Philadelphia, constructed by The Fabric
Workshop

of stars in translucent silk, washed linen, and muslin. Lipski was the conceptual initiator and product overseer. To mark the first time he had focused so intensely on variations around a single theme, he adopted *Who's Afraid of Red, White & Blue?* as the series title. His reflections on the formal and emotional impact of bolts and strips of cloth patterned with a symbolically potent icon run the gambit from the intimate flag book *Who's Afraid of Red, White & Blue? #25* (p. 30) or human-scaled *American Flag Ball #2* (p. 31), to multi-story, site-specific installations like *Who's Afraid of Red, White & Blue? #31* and *Black by Popular Demand.*[19]

Lipski asserts he does not set out deliberately to create overt political symbols. Each object in this series, however, is linked to decidedly American metaphors. Root balls of young trees, wrapped and packed in flags, become ruminations on the pioneering American dream of westward movement and Manifest Destiny. Flags constructed of pure white Irish linen tied with silver tassels invite viewers to retrace a nativist vision of this icon from the immigrant perspective. Flags immersed and contained in industrial glass tubing or flags deconstructed and reassembled as woven tapestries and jigsaw puzzles suggest Lipski's belief that the flag has become dangerously over-politicized. Lipski's flags initially appeared in several exhibitions throughout the United States without provoking controversy or attack. Then, in 1996, *American Flag Ball #3,* a large ball of wound fabric printed in red, white, and blue that had been on display for five years on the grounds of Long Island University's C.W. Post campus in Brookville, New York, was slashed with a razor knife. As Elizabeth

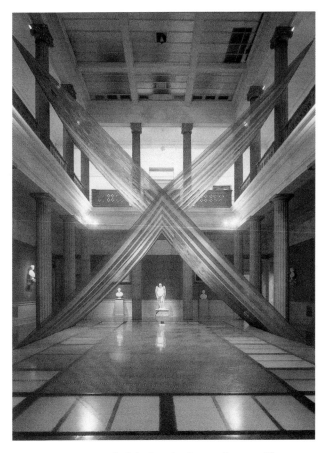

Black by Popular Demand, 1990, silk organza, 360 x 360 x 252 inches, installation view at The Corcoran Gallery of Art, Washington, DC, constructed by The Fabric Workshop

Who's Afraid of Red, White & Blue? #25,
1990, muslin, plastic, steel, 34 x 14 x 2¹/₂
inches, Collection of the Bawag Foundation,
Vienna, Austria

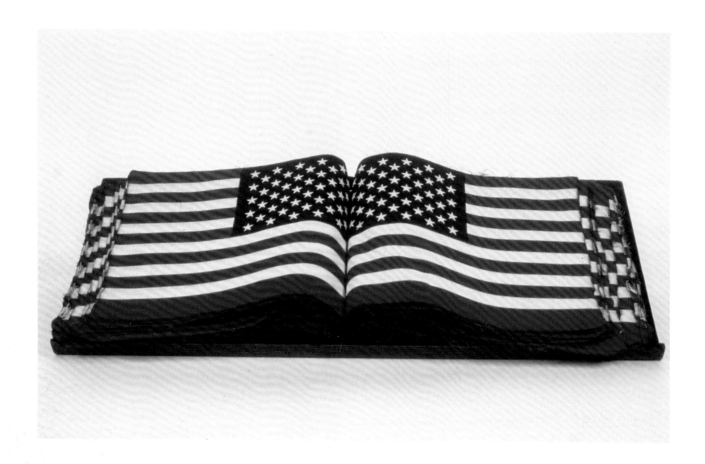

American Flag Ball #2, 1990, muslin,
13 balls, 32 inches in diameter each,
installation at Beaver College Art Gallery,
Glenside, Pennsylvania, in collaboration
with The Fabric Workshop

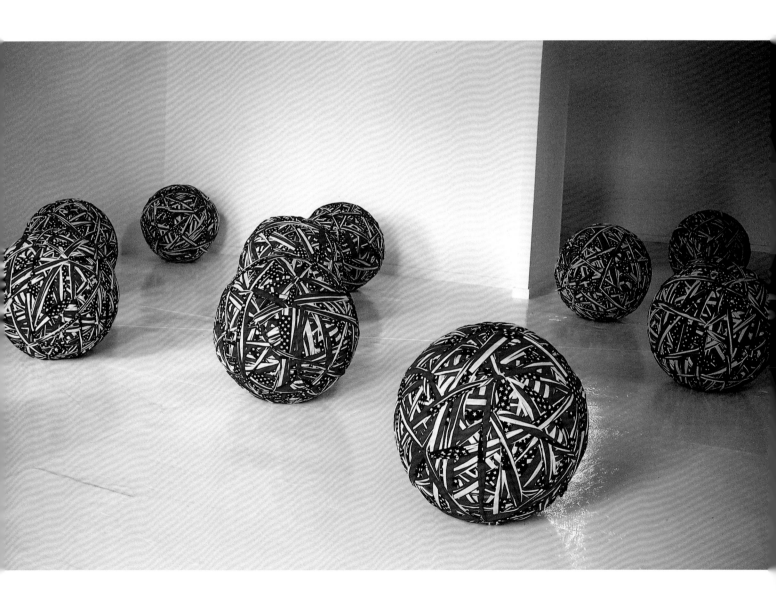

Untitled, 1991, brass, wax, 27 x 6 x 5 inches,
Collection of Susan and John Steinhardt,
New York

Hess wrote in *The Village Voice* at the time, "A gang of patriots had apparently rescued Old Glory by knifing it to death."[20] No stranger to controversy and transgression, Lipski was nonetheless surprised and infuriated by the attack. He felt "the zealots have had their way."[21] The perpetrator was never apprehended and the damaged *American Flag Ball #3* languishes in storage, Lipski's personal battle scar from the culture wars.

Sound and Fury, Smoke and Fire

In a world where time is a sense, like sight or like taste, a sequence of episodes may be quick or may be slow, dim or intense, salty or sweet, causal or without cause, orderly or random, depending on the prior history of the viewer.

Einstein's Dreams[22]

In 1991, Lipski shifted theme and content to create a tightly conceived thematic exhibition dominated by white candles. Unlike *Who's Afraid of Red, White & Blue?*, which wound emotionally and conceptually around a visibly public icon, in this cycle of untitled sculptures, Lipski mingles a deliberate sense of nostalgia with a strong spiritual or emotive quality. He explains, "I started working with candles when my cousin Brenda got cancer and the show, as I did it, felt almost like a prayer. I don't think I have ever had that kind of purpose or intensity or idea in anything I have done since." Coupled with Lipski's perfect pitch in selecting highly charged candle containers—antique beds, musical instruments, instrument cases—the neutral white candles allow him to simulate the "tactile and visual properties of substance."[23]

Lipski's white-candle works operate in a world suspended between presence and absence, purity and eroticism, warm and cold, soft and hard. Like glass, the compelling material characteristic of wax is its physical changeability, a property that readily translates into sensuality. The pieces in this series that refer to music are especially poignant. *Untitled* (1991) is constructed of a trumpet iced with a heavy coat of pristine white wax as drips form icicles along the ledges of the vertically positioned instrument. The mouthpiece becomes a candlestick with a stately taper applying the *coup de grace* to silence this often-raucous brass instrument. Other untitled works from this series that make musical references include a weathered harp case (p. 34) propped open to exhibit an interior tightly packed with squat, round, unlit tapers and a sousaphone case splayed to reveal a legion of tiny white candles crammed together like so many blind, white maggots. By subverting the function of the instruments and their casings, Lipski heightens our awareness of the music that remains unplayed and unheard.

The collaborative, location-specific exhibitions Lipski realized with Grumman in Long Island and The Fabric Workshop in Philadelphia inspired The Contemporary Arts Center in Cincinnati to invite him to create a new body of work in collaboration with a local industry. After considering U.S. Playing Cards, Baldwin Piano, and General Electric, Lipski chose to work with The Verdin Company, the oldest and largest bell manufacturer in the United States. The resulting collaboration, *The Bells,* is a compelling continuation of the ethereal spirituality of the candle pieces. Lipski began this project with a heightened awareness of the many

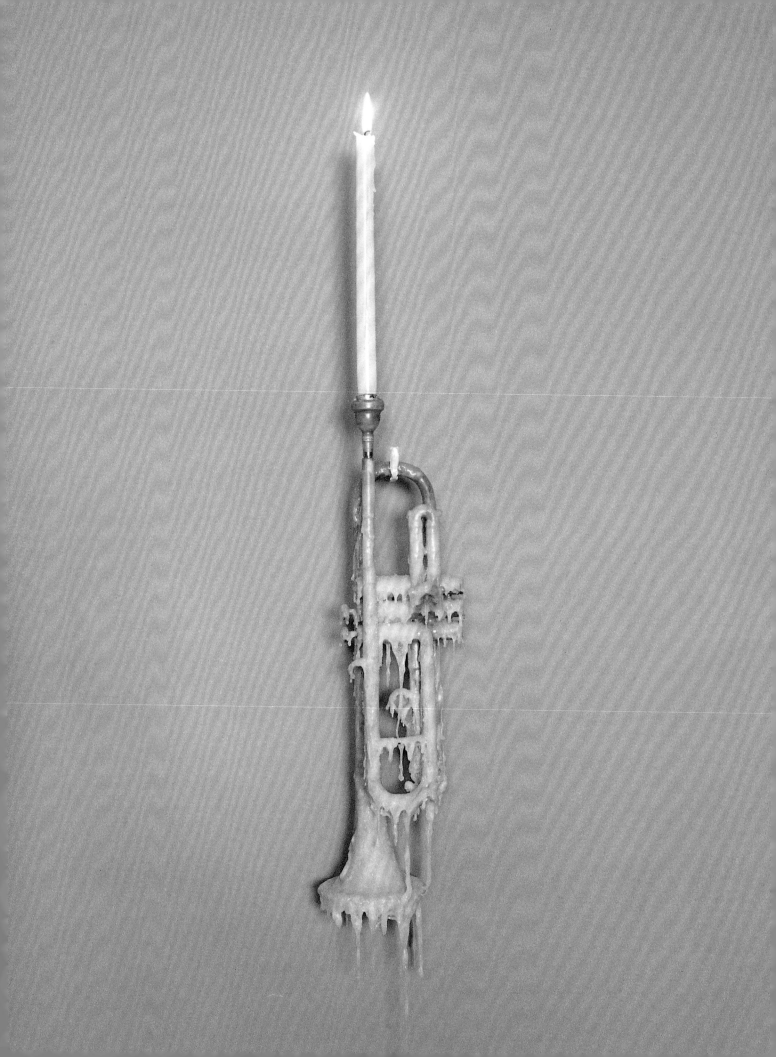

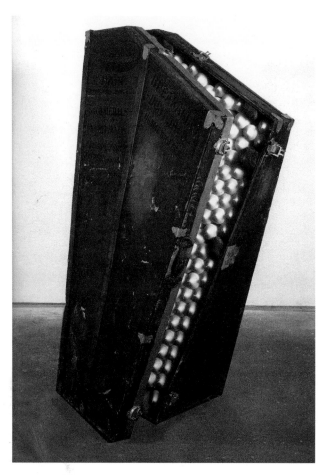

Untitled, 1991, wood, wax, paper, steel, brass, 74 x 70¹/₂ x 23 inches, Collection of Denver Art Museum, Museum Purchase with funds from the Alliance for Contemporary Art

symbolic and psychological associations accorded bells, from freedom and religious observation to joyous celebration and solemn memorial commemoration. He also thrived on the idea of a new site-specific challenge. "I love going through any factory, finding out about something I didn't know," Lipski says. "It is a great challenge and very stimulating. You have to discover the nature of their materials, what their capabilities are and the culture of the place. What I make is so varied that I like being given a logical starting point."

In a conscious digression from his practice of sequential numbering, Lipski created symbolic titles for the four large works that comprise the exhibition—*The Belles, Leaves of Grass, In Memory of Silent Deeds,* and *Der Kleiner Bells.* Each balances allusions that shift subtly between spirituality and religion and the desires and needs of the secular world. *In Memory of Silent Deeds* (p. 78) is a massive bronze carillon bell that pulses with 49 small bells connected through a circulatory system of wires. The large bell, which Lipski discovered engraved with the words "Silent in Memory of Andrew Deeds, Jr. 1909–1917," he recast to give the silent, commemorative object a new voice. The confusion of religious theologies and popular culture in contemporary American life are addressed in the evident symbolism of *The Belles* and, especially, *Leaves of Grass* (p. 36). *The Belles,* with its phalanx of eight faceless feminine mannequins draped in the purple garb of Christian resurrection, emphasizes spirituality's denial of the physical world. *Leaves of Grass* recalls poet Walt Whitman's masterwork celebration of the self, universal brotherhood, and the cycle of life. Two identical

The Belles, 1991, bronze, linen, silk chiffon,
tulle, mixed media, eight pieces, 66 x 48 x 48
inches each, Courtesy of the artist and
Galerie Lelong

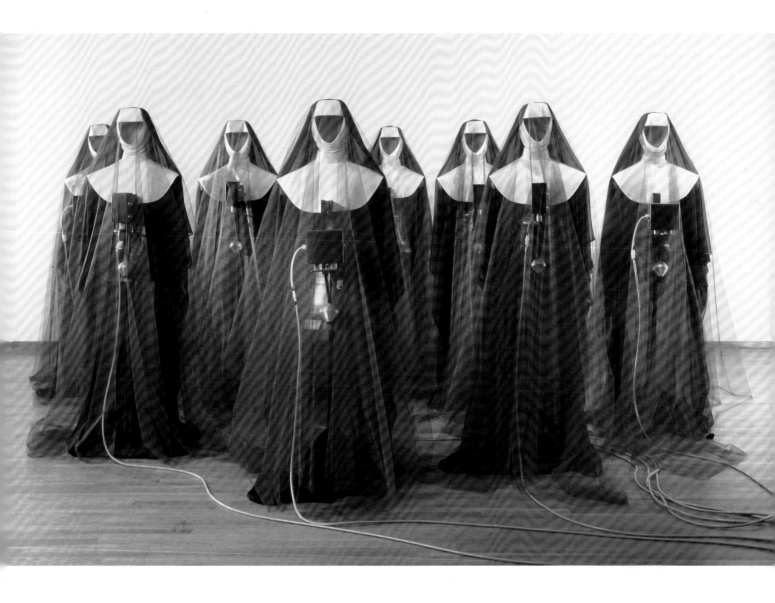

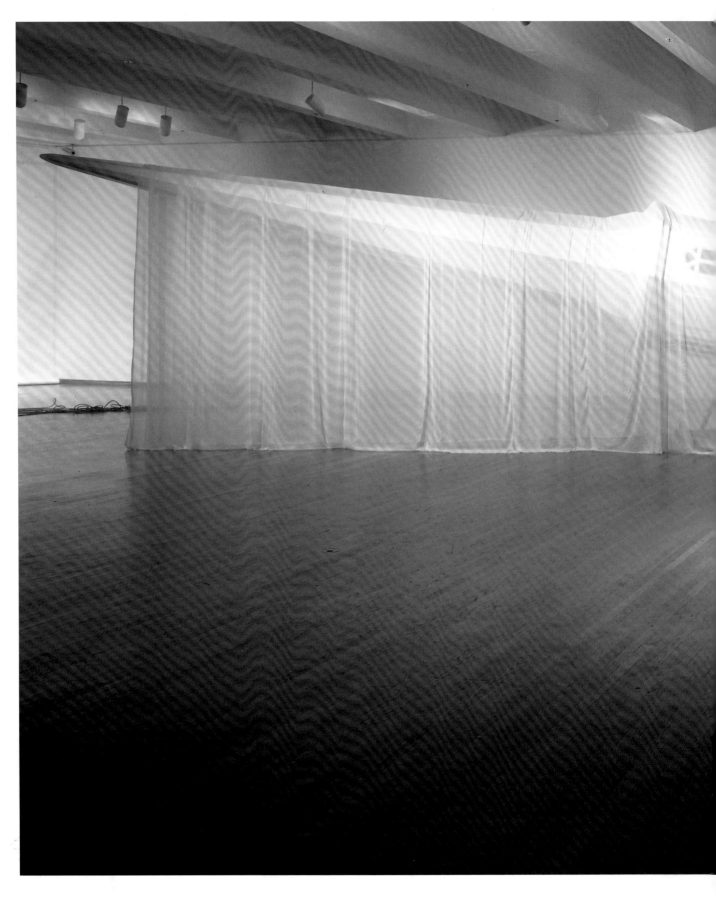

Leaves of Grass, 1991, fiberglass, silk
chiffon, mixed media, 120 x 624 x 60 inches,
installation view at The Contemporary Arts
Center, Cincinnati, Ohio

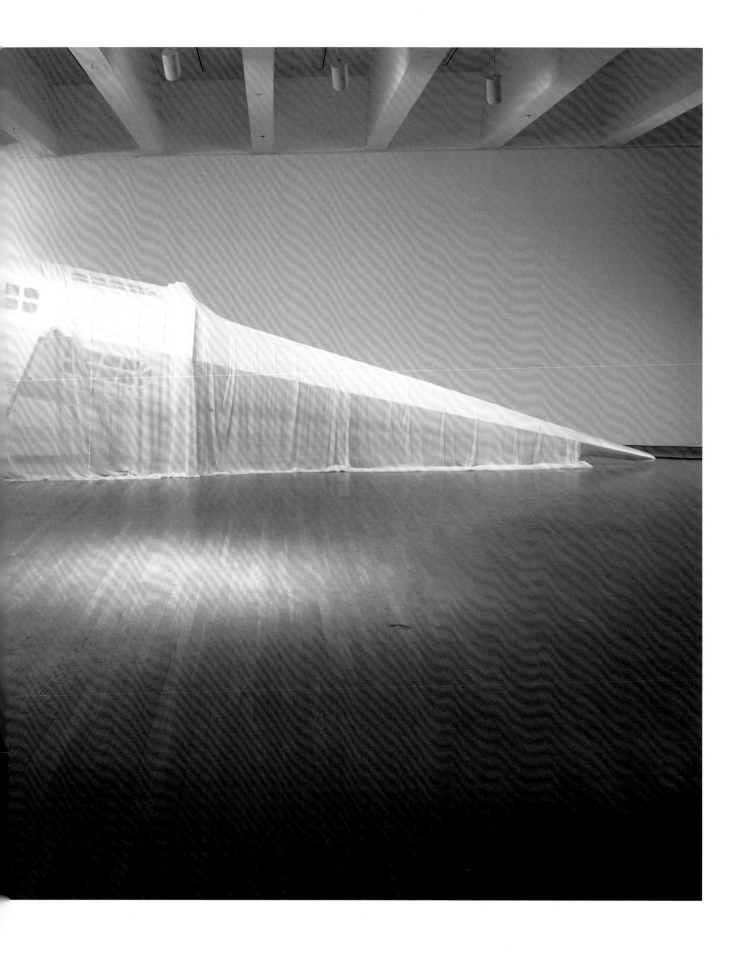

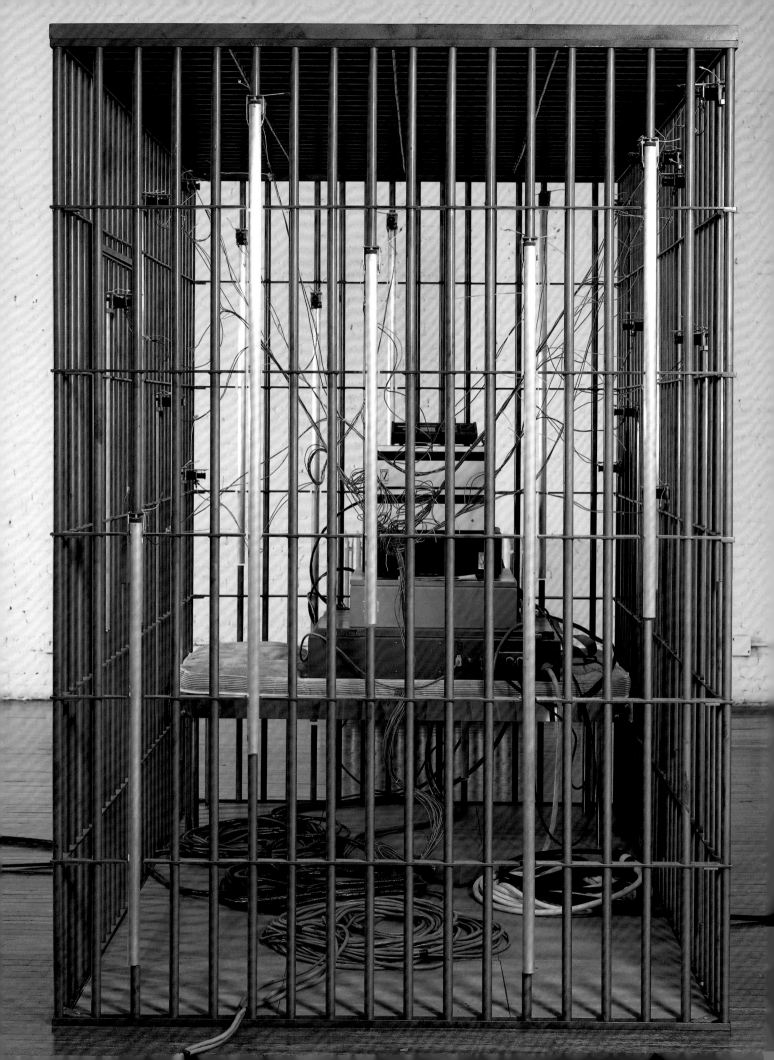

Der Kleiner Bells, 1991,
steel, mixed media,
120 x 96 x 96 inches

church steeples, shrouded in a mass of white gauze, married at their bases and pivoted on a triangular base like a seesaw, suggest scales that balance the hierarchical precepts of religion.

Bells produce sound and music, both of which play a crucial role in *The Bells.* The audio elements, however, make themselves apparent as much by their absence as by their presence. Commissioned by Lipski, composer Brad Feidel orchestrated an elaborate musical score to enhance the visual experience of the exhibition without openly manipulating viewers' emotions or perceptions. Undermining continuity as understood through traditional musical time, Feidel's 30-minute composition is structured so it can be captured only in 15-minute segments, punctuated as it is at intervals by Westminster chimes that demarcate the passage of time. Viewers who come and go catch snatches of music but cannot measure it against the completeness of the full melody's flow.

The heart of the installation, both in form and function, is *Der Kleiner Bells.* This gigantic music box with hanging bar chimes—a humming inner core of computers from which a tangle of colored wires emanate like veins and arteries—suggests a place of protection from molestation but also a confining, jail-like space that inhibits freedom of movement and physical interaction. As in many of Louise Bourgeois' *Cell* sculptures, the psychological associations in Lipski's piece contain powerful symbolic images that penetrate emotional distance by the way they emphasize the trade-off between security and freedom, submission and dominance, autonomy and confinement. *Der Kleiner Bells* is both confining and secure, sanctuary and trap. It is a mysterious and threatening container that suggests the most powerful prisons are found in the imagination.

The social element in any Lipski collaboration is best exemplified by *Oral History,* an exhibition he created in 1994 at the invitation of the Southeastern Center for Contemporary Art in Winston-Salem, North Carolina. In the same way *The Bells* was site-specific to Cincinnati, *Oral History* connected Lipski directly to the roots of this historic center of the tobacco industry. *Oral History* also provided him the opportunity to create a visual journey into a personal obsession. Lipski's research was typically exhaustive. He visited tobacco farmers, tobacco auctions, factories, and even a tobacco museum before considering how to approach this subject.[24] "Cigarettes are as loaded an icon for me as they are for the culture," he explains. "I started smoking when I was 13 or 14 years old and have smoked all my life. I love cigarettes and I hate cigarettes. I have a tremendous depth of feeling about them that spans the spectrum of emotion." As in his appropriation of the American flag, Lipski began by acknowledging that simply incorporating cigarettes and smoking paraphernalia as subject matter and raw material in his art would be provocative. His challenge in *Oral History* was to find a way to use cigarettes as an art material on a formal basis, to find meaning but not be perceived as carrying a banner for any particular point of view.

Coining the title *Tobaccolage* (p. 40), Lipski fused the notions of *bricolage*[25] and *assemblage.*[26] Jasper Johns's oft-quoted note to himself to "take an object.

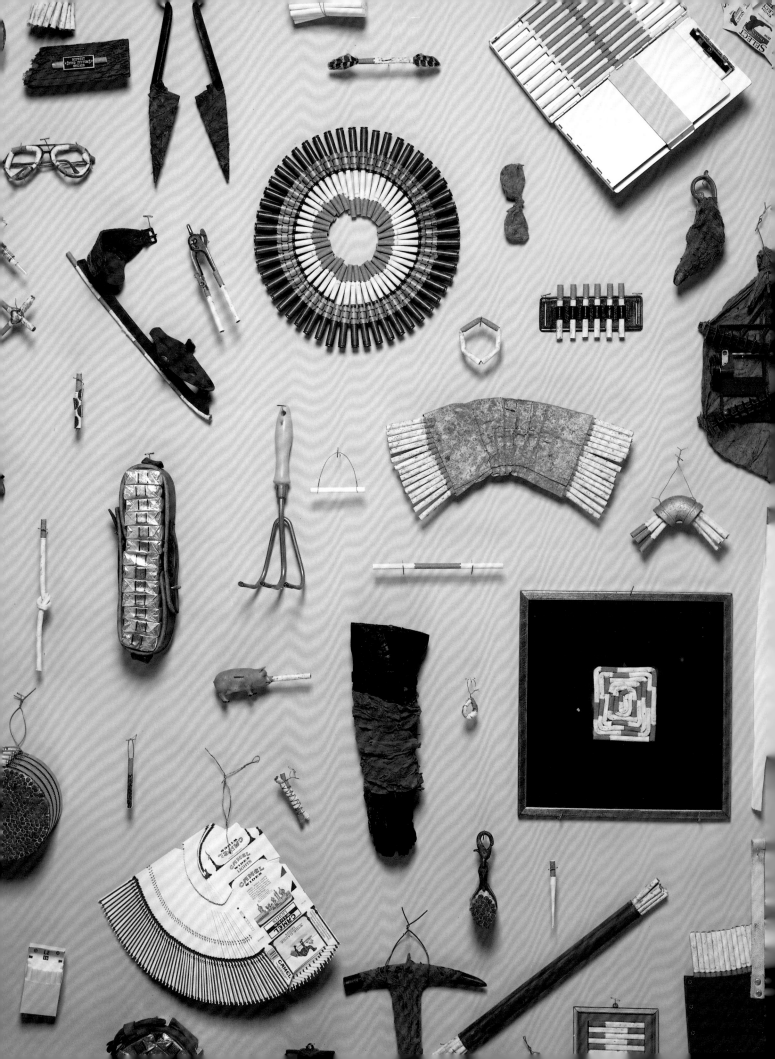

Tobaccolage (detail), 1993, mixed media, dimensions variable, installed at the Southeastern Center for Contemporary Art, Winston-Salem, North Carolina, Collection of the artist

Do something to it. Do something else to it,"[27] served as inspiration. Lipski began "doing whatever I could think of to cigarettes or cigarette packages, without thinking about what it meant." This lack of premeditation allowed Lipski to forage widely for objects. As a result, the accoutrements of cigarette mass-production are married to baby bottles, glass pipettes, and bullet casings to create challenging, often sardonic sculptures that demand and hold our attention. In *The Humidors 1961–1990* (1993), a series of wall-mounted glass cases that look like common medicine cabinets, Lipski symbolically documents the 300,000 cigarettes he smoked between 1961 and 1990. This cigarette diary advances a highly personal, almost confessional narrative in the sculptural terms of industrial minimalism: viewers can see the years the artist cut down or quit, measuring stressful times of intense inhalation against periods of relative calm. Compositionally, the work is streamlined, using factory fabricated metal and glass vitrines to frame geometric patterns and numbers that, until their contents become apparent, appear to be formal studies in brown and white. Unlike the spiritual specificity that dominates *The Bells, Oral History* is a wide-ranging exercise in sculptural styles that delves freely into the author's consumptive nature, the complex social, political, and economic concerns related to tobacco and the minimalist canon.

The Humidors 1961–1990, 1993, cigarettes, tobacco leaves, aluminum, plexiglass, thirty elements, 32 $^1/_4$ x 32 $^1/_4$ x 4 $^3/_4$ inches each, installation view at the Southeastern Center for Contemporary Art, Winston-Salem, North Carolina, Collection of the artist

The Humidors 1961–1990 (detail), 1993, cigarettes, tobacco leaves, aluminum, plexiglass, thirty elements, 32 $^1/_4$ x 32 $^1/_4$ x 4 $^3/_4$ inches each, Collection of the artist

Preservation and Decay

There is a place where time stands still.

Einstein's Dreams[28]

In art, action is always becoming inertia, but this inertia has no ground to settle on except the mind, which is as empty as actual time.

Robert Smithson[29]

Glass always has figured prominently in Lipski's art. Never inert but never fully deteriorating, it is one of his favorite materials. Glass exists in a peculiar condition of temporal imbalance: as a "supercooled" liquid straddling two physical states, it is both the antitheses and epitome of entropy. The theatrical, risk-taking aspect of working with glass is obvious in works like *Free Reef,* with broken shards spilling out from a circle of tin buckets, or the fragile glass handle of the ax in *Pilchuck #90–11* (1990) (p. 71). Glass' state of permanent suspended animation is apparent in the magnificently perverse *Water Lilies* series, where Lipski joins the technical precision of industrial glass evacuation pipes and boiling flasks manufactured by Corning Glass with the fragility and perishability of organic goods. Mediating the preservation/decay dichotomy that dominates these works is a liquid preservative soup that, like formaldehyde, sustains the organic integrity of the material contained within. Water lilies are ethereal flowers and this series title evokes the natural elusiveness of the flower as well as the obsessive, constantly changing nature of Claude Monet's garden at Giverney, depicted as it waxed and waned in the French Impressionist's renowned *Water Lilies* paintings (1899–1925). Lipski's *Water Lilies* confer the values

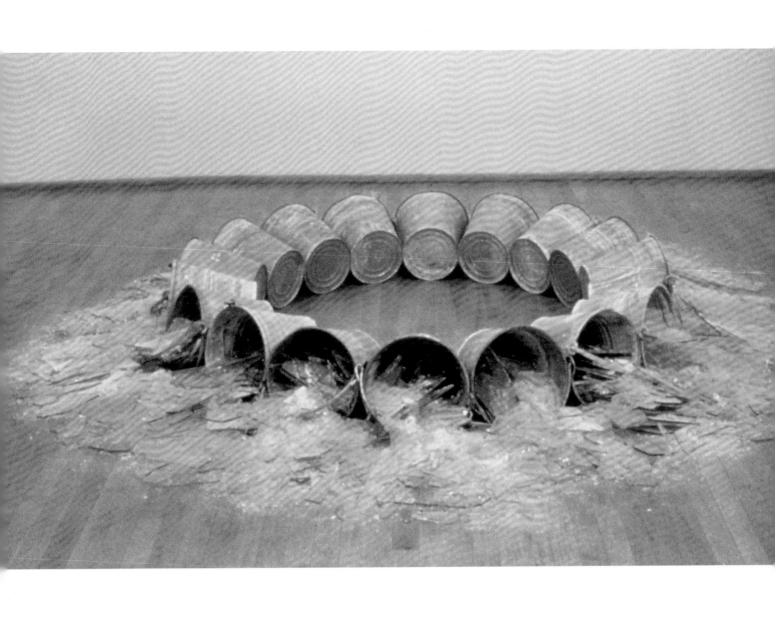

Free Reef, 1987, glass, steel, 10¹/₂ x 100 x
100 inches, Collection of Terri Hyland

Water Lilies #58, 1990,
glass, herbs, preservative solution, steel
8 x 132 x 2 inches,
Collection of The Detroit Institute of Arts
Founders Society Purchase, W. Hawkins
Ferry Fund, Andrew L. and Gayle Shaw
Camden Sculpture and Decorative Arts Fund,
and Mary Moore Denison Modern Art Fund

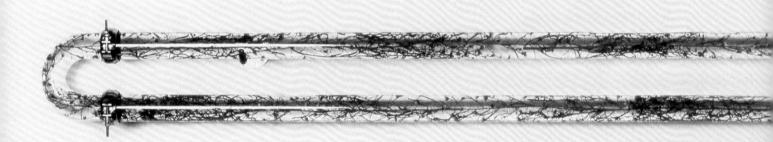

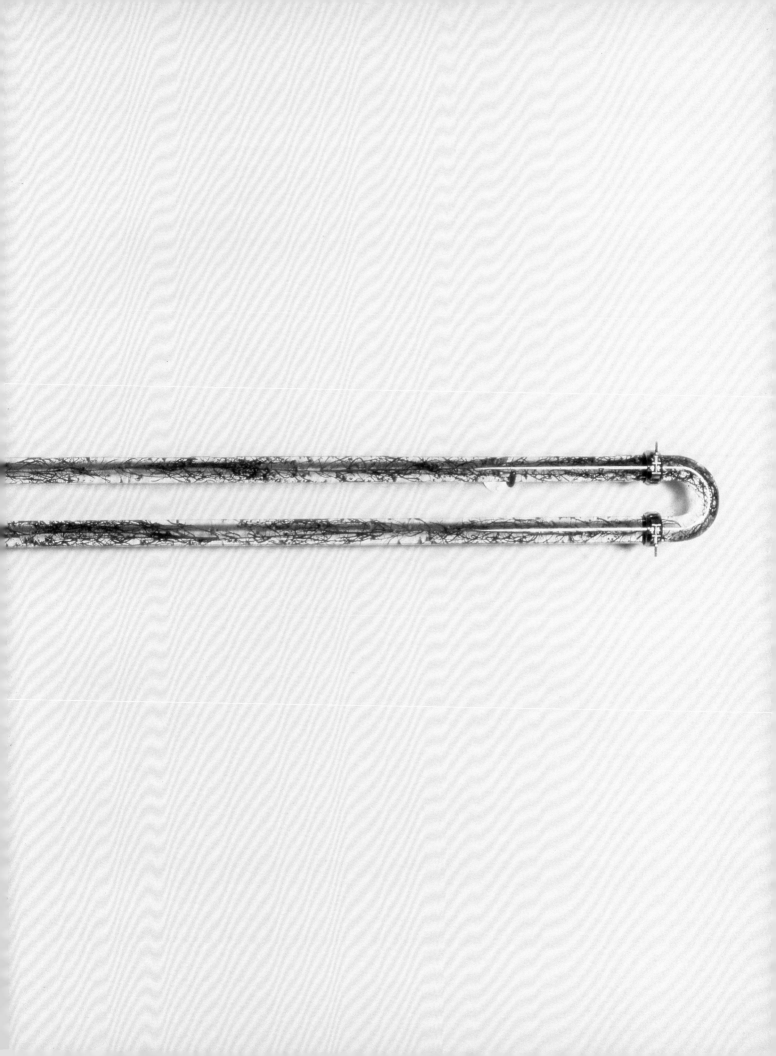

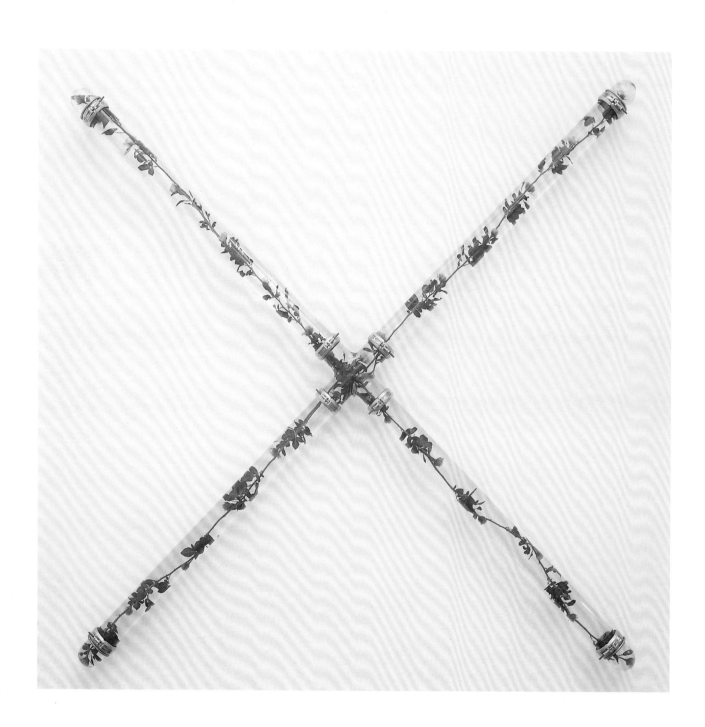

Water Lilies #32, 1990, glass, roses, preservative solution, steel, 103 x 103 x 5 inches, Collection of the Corcoran Gallery of Art, Washington, DC, Gift of the Women's Committee of the Corcoran Gallery of Art

right: *Water Lilies #32* (detail)

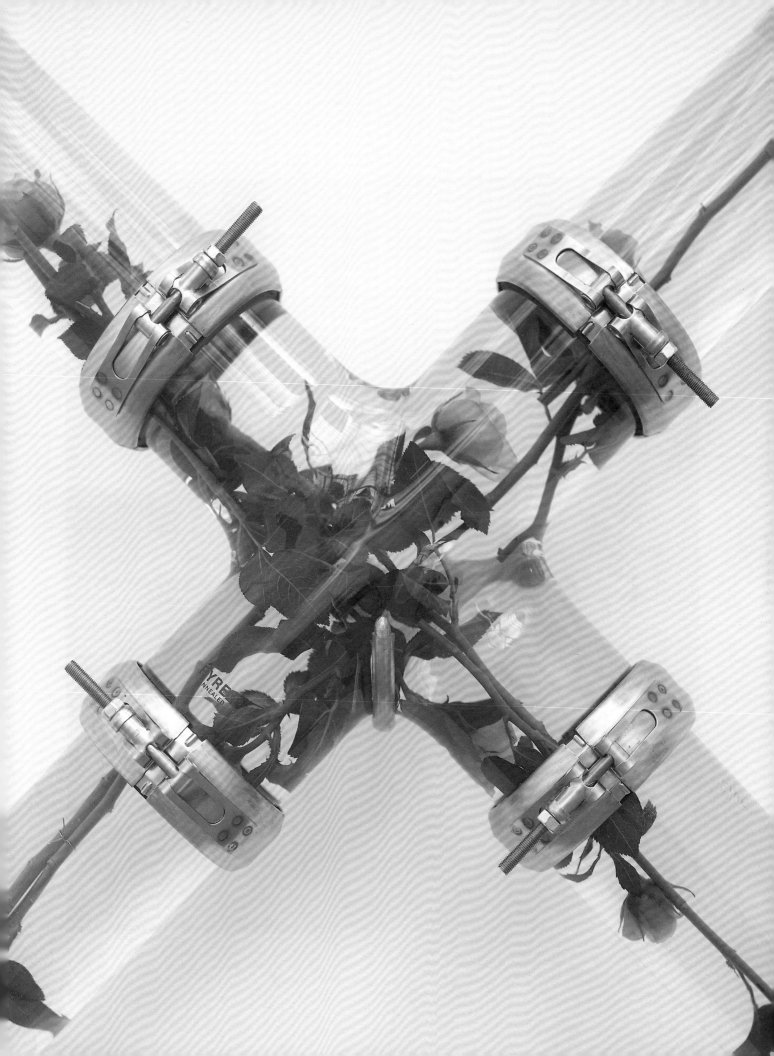

Farm Tool, 1993, 1932 Ford truck,
four 200-liter corning boiling flasks, yucca
plants, preservative solution, Courtesy of
Corning Incorporated, Corning, New York

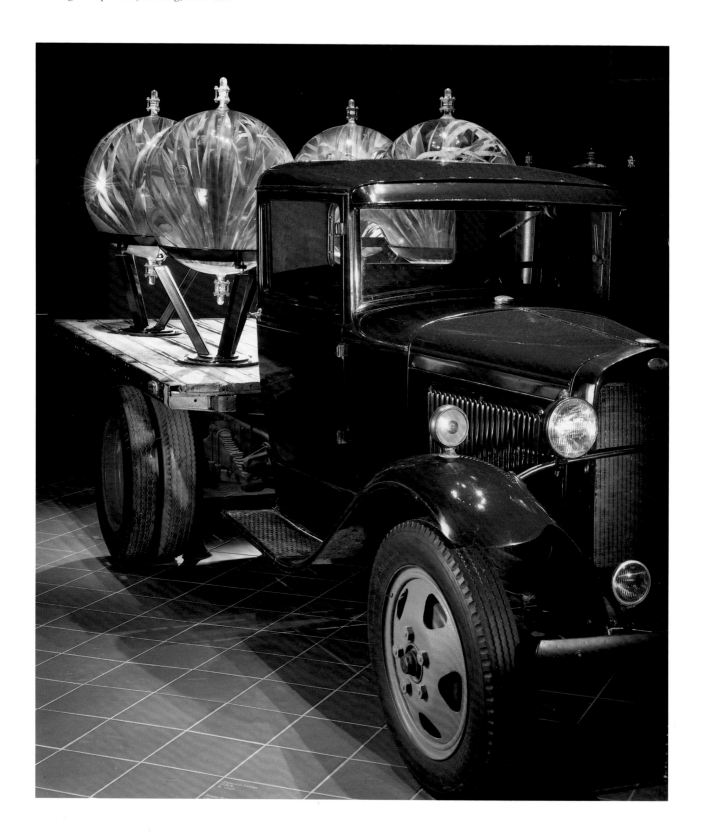

associated with permanence on all manner of normally ephemeral, perishable objects. Consider *Water Lilies #58* (1990) (p. 44), two long glass tubes connected by graceful elbow joints and stainless steel coupling gaskets that encase herbs, or *Water Lilies #32* (p. 46), a large glass "x" filled with red roses. In each case, the central image is composed of objects of nourishment or desire normally consumed and disposed of unceremoniously.

Lipski's *Water Lilies* occupy a territory traditionally associated with *nature morte*. Here, unlike painted depictions of flowers and fruit, the artist's aesthetic action positions flowers, fruits, or vegetables in a state suspended between waking and sleeping, life and death. *Farm Tool* (1993) exemplifies this deft and often disturbing collision. Combining a 1932 Ford flatbed truck with four, 200-liter Corning boiling flasks stuffed with bright yellow yucca plants floating in clear liquid, Lipski couches his ideal of beauty as a concept that finds room for the industrial cleanliness and smooth lines of an early-model truck and industrially manufactured glass forms. In life, yucca plants are evergreens; here they are kept "ever green" through a transparent entombment. Aesthetically eternal, the yucca's angular blades are not unlike the classic lines of the Ford and, like the automobile, project a nostalgic retrospective take on the by-gone era of modernism.

The Forest and the Trees

Suppose that time is not a quantity but a quality, like the luminescence of the night above the trees just when a rising moon has touched the treeline. Time exists, but it cannot be measured.

Einstein's Dreams[30]

Lipski continued to expand the idea of large-scale *nature morte* in his room-sized installation *The Cauldron*, (p. 50) created in 1996 for The Parrish Art Museum. Here, Lipski reconfigured trees into found objects. Resurrected from a massive fire that consumed a large portion of the Westhampton, Long Island, pine barrens in 1995, these trees form the locus of what appears to be a hybridized ecological experiment. Joined at the roots by an engulfing ball of bunting, two charred and fragile coniferous skeletons hover above our heads, suspended horizontally over a bubbling, cauldron-like pool. The trappings of a laboratory—humming and clicking of air compressors, the tangle of transparent plastic hoses and tubes delivering unidentified liquids to and from a variety of suggestive machines—calls to mind Frankenstein's workshop as well as the eerie biomechanical rhythms of a hospital intensive care unit. *The Cauldron's* theatrical setting plunges us *in medius res* into a suggestive narrative environment where the architecture of the room becomes the defining parameter of the work. In effect, we cross over the fourth wall that normally sets audience apart from actors. Entering the work, we activate it and become part of the tableau.

Sirshasana (1999) (p. 53), a monumentally scaled public artwork Lipski was commissioned to create for the entrance to the Grand Central Market at New

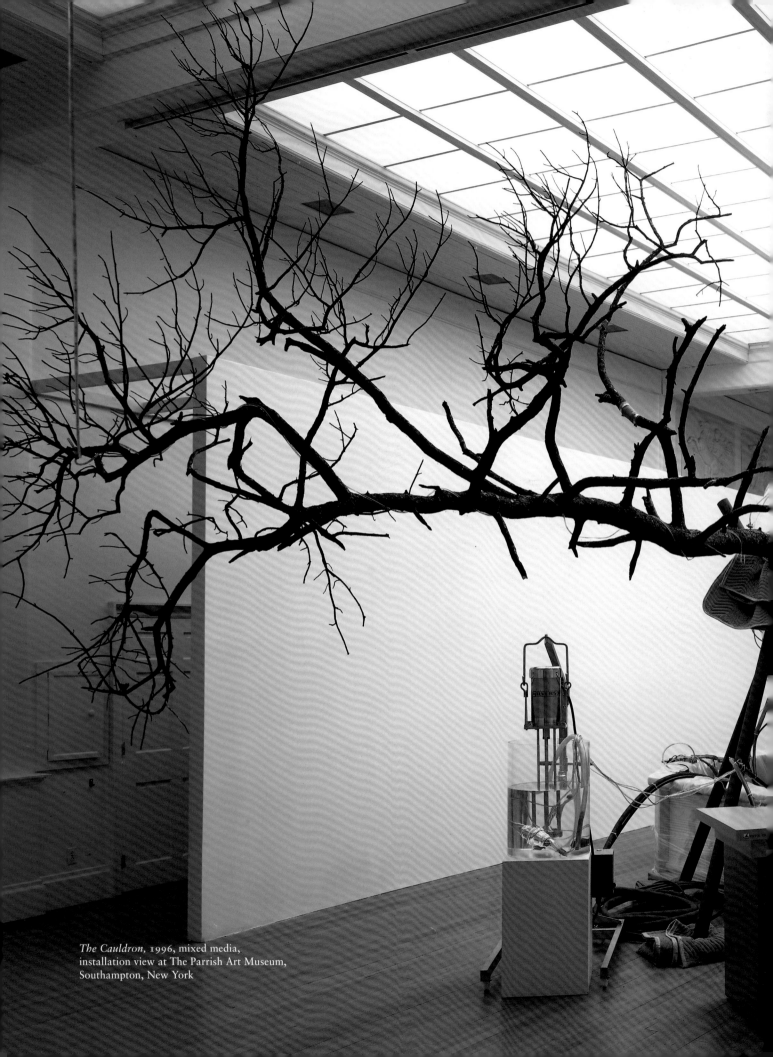

The Cauldron, 1996, mixed media,
installation view at The Parrish Art Museum,
Southampton, New York

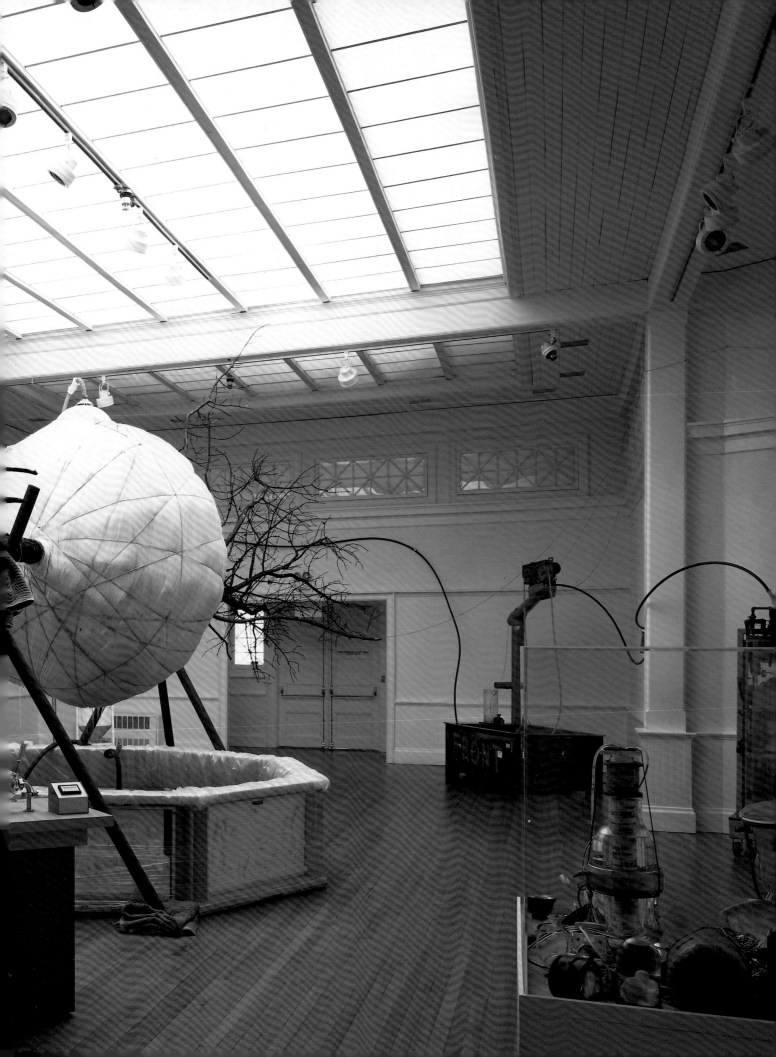

Sirshasana, 1999, mixed media,
216 x 300 x 300 inches, permanent
installation at Grand Central Market at
Grand Central Terminal, New York,
New York, photo © Peter Aaron/Esto

York's Grand Central Terminal continues his concern with the symbolic potential of trees to mark the boundary between the imagined and the real. "Ten years ago, I looked at Banyon trees in Hawaii, and thought, 'I want to get a Banyon tree and manipulate it, get objects to intertwine in the roots and branches, to blur the lines between what is the tree and what is the object.'" In developing the concept for *Sirshasana,* Lipski worked with Jonquil LeMaster, an artificial tree maker from the Pacific Northwest. Suddenly Lipski did not have to rely on finding or manipulating the real thing. "When I started working with Jonquil it occurred to me that 'aha, I don't have to wait years for trees to grow. I'm a sculptor. I can make them do whatever I want.'"

The result is a 3,000-pound olive tree fabricated in polyester resin and aluminum, its inverted branches adorned with 5,000 glittering Austrian chandelier crystals, that spans 25 feet across the main market entrance. The tree's root system, covered in gold and joined to the trunk by a band of cast acanthus leaves, becomes the base of this hybrid *lustre.* In *Sirshasana,* Lipski responded to the specificity of this public site by melding two distinct influences. He notes, "In some sense the work should refer to what is going on in Grand Central Station. The sky mural in the main concourse gave me the idea that, just like in the old days, the market should be under a tree. The crystals echo the stars in the mural. And the great chandeliers in the Vanderbilt Hall and elsewhere in the station suggested that my tree could also be a different kind of chandelier."

In *Sirshasana* and the works that followed, the notion of integrity of the found object collides with

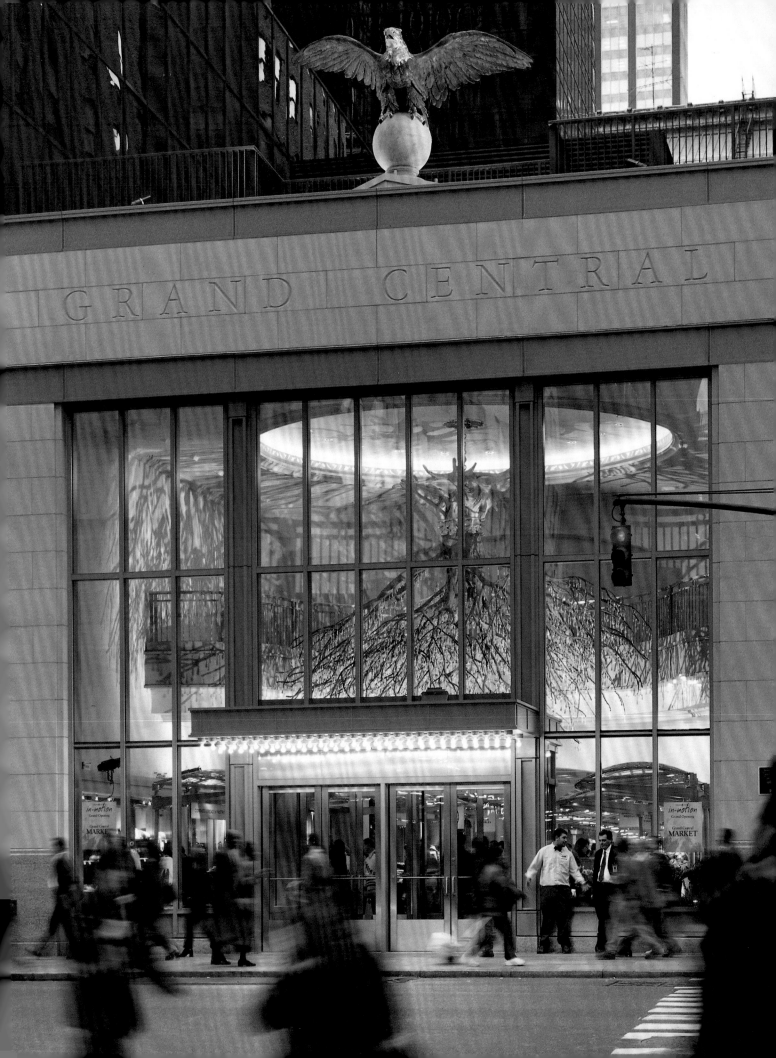

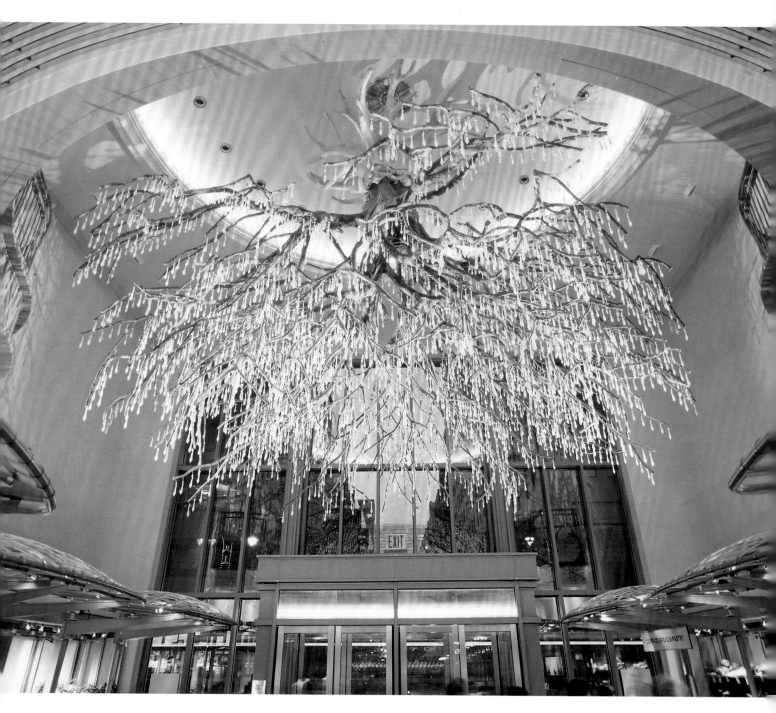

Sirshasana, 1999, mixed media, 216 x 300 x 300 inches, permanent installation at Grand Central Market at Grand Central Terminal, New York, New York, photo © Peter Aaron/Esto

more traditional approaches to sculpture. Viscerally attracted to the possibilities of using familiar shapes to create entirely new forms, Lipski embarked on a series of works based on the idea of a tree that had grown around or become intertwined with a manmade object. Works in the *Exquisite Copse* (p. 87, 88) series are almost, but not quite, believable as something that occurs naturally.[31] In this series, time is speeded up: what should take decades or centuries—a log engulfing a doorknob or draped over an ax handle—becomes immediate reality.

New Things Out of Old Things

Robert Morris once said, "every difference makes a difference." And that's true, but every difference doesn't make a big difference.

Donald Lipski

In this world, time is a visible dimension. Just as one may look off in the distance and see houses, trees, mountain peaks that are landmarks in space, so one may look out in another direction and see births, marriages, deaths that are signposts in time, stretching off dimly into the far future.

Einstein's Dreams[32]

Over some 15 years, Lipski amassed so much stuff in his studios, first in lower Manhattan and later in much larger quarters in Brooklyn, he ran out of racks to warehouse things or even floor space on which to pile it. He had a problem on his hands. Sensing creative possibilities, he installed everything he had collected up to that point—tractor tires, snowshoes, hockey masks, shovels, work gloves, bandoleers, skeins of yarn, bars of soap—in the Grand Lobby of the Brooklyn Museum of Art in a 1993 installation entitled *Pieces of String Too Short to Save* (p. 56). Unlike *Gathering Dust,* or any successive grouping of manipulated and reinvented found objects Lipski has created, *Pieces of String Too Short to Save* is less a rearrangement of familiar outlines of a common complement than a direct challenge to the notion of conferring value or art status on objects. "The title is paradoxical in this sense—what I'm showing here is not sculptures I've made. . . . Sculptures I've made are all very specific and considered and put together. These are all objects that were in my studio that I never managed to make sculpture of."[33] But the installation is sculpture, a work of art that pays homage to the 1960s scatter art of Robert Morris, Richard Serra, and Barry Le Va, yet communicates in a voice that is decidedly more eclectic and open in its choice of words. Lipski composed the elements of *Pieces of String. . .*, "quite specifically for its inherent attributes—beauty, intrigue, or metaphoric content...."[34]

Pieces of String Too Short to Save was a physical and psychological breakthrough for Lipski. Having emptied the studio of the thousands of objects that kept him company and inspired him, he ventured to adopt a more streamlined studio approach. But what to do with all that stuff? No matter how much Lipski gave away, or discarded, the obsessive collector in him could not forsake all his treasured objects. A new artwork was born: *Pieces of String Too Short to Save* (p. 58, 86) was transformed into a more solidified statement consisting of 12 specially designed storage cages, each crammed to capacity. Contained in these cages, the value of Lipski's objects no longer lies in their role as catalysts for material inspiration, but in their potential. Each case

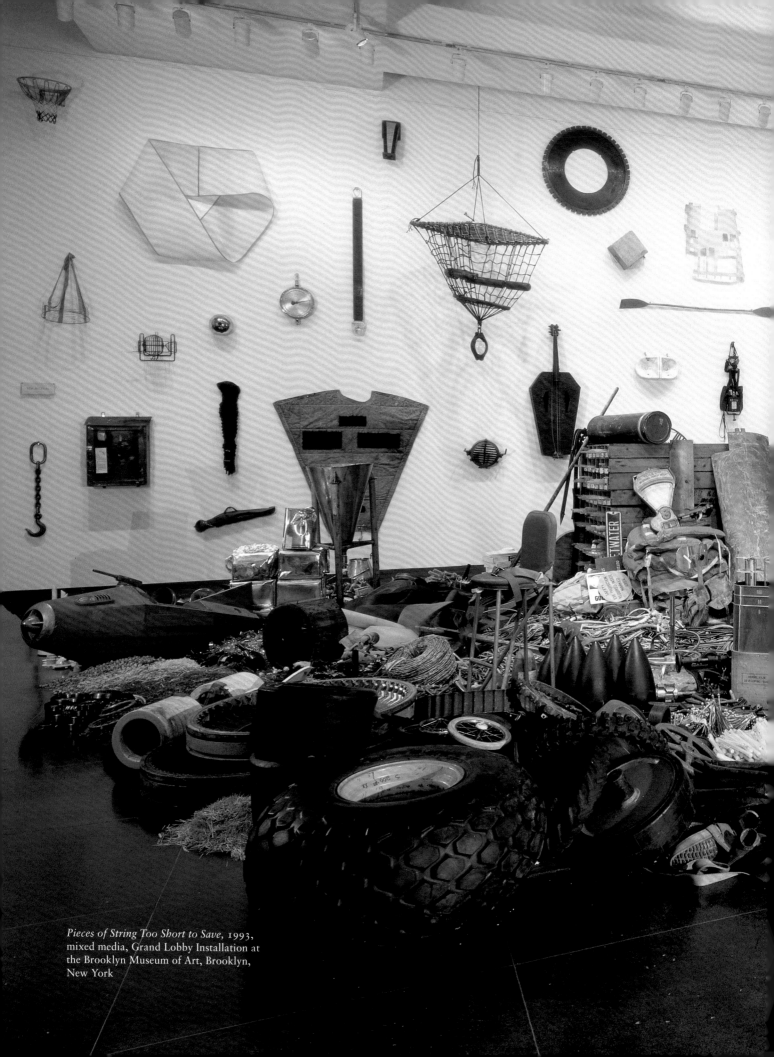

Pieces of String Too Short to Save, 1993,
mixed media, Grand Lobby Installation at
the Brooklyn Museum of Art, Brooklyn,
New York

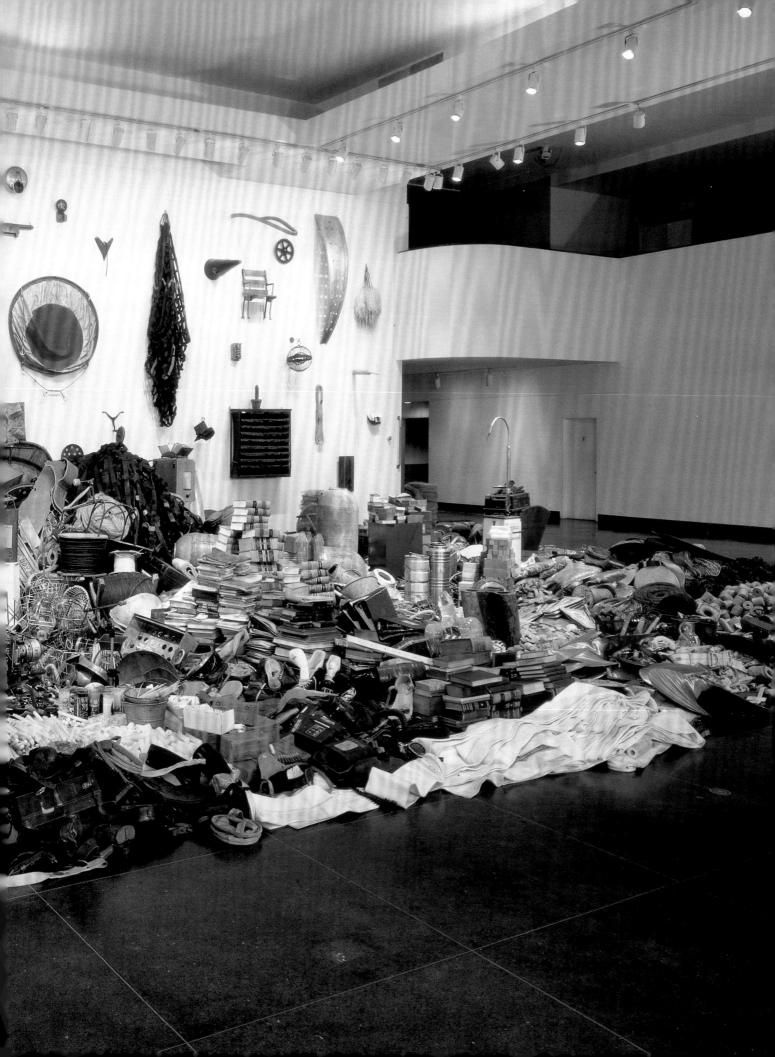

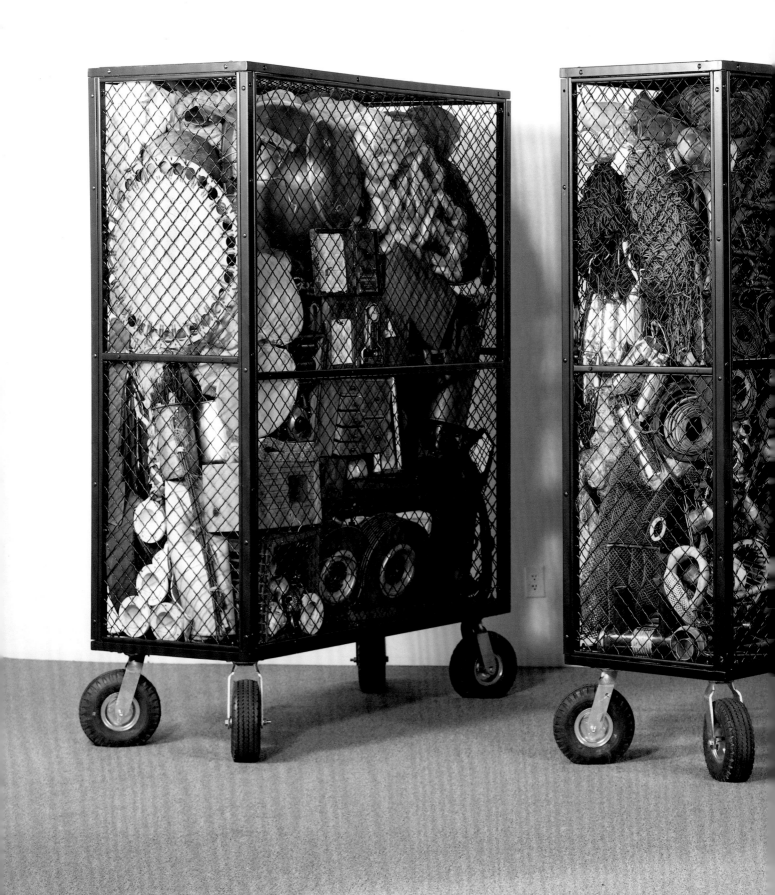

Pieces of String Too Short to Save (detail),
1998, mixed media, twelve elements,
80 x 60 x 24 inches each, Courtesy Carl
Solway Gallery, Cincinnati, Ohio

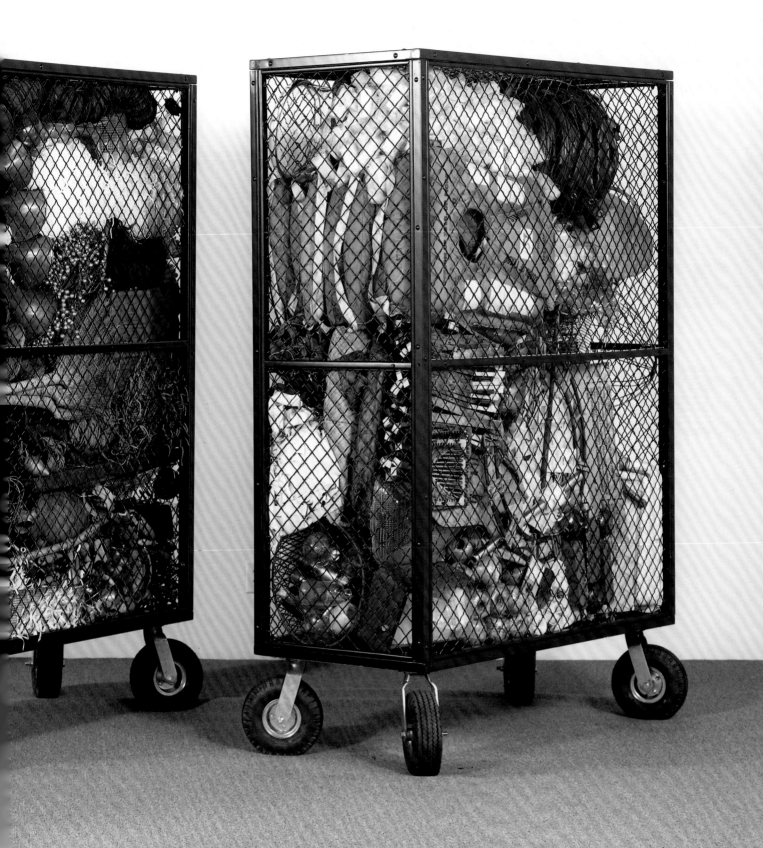

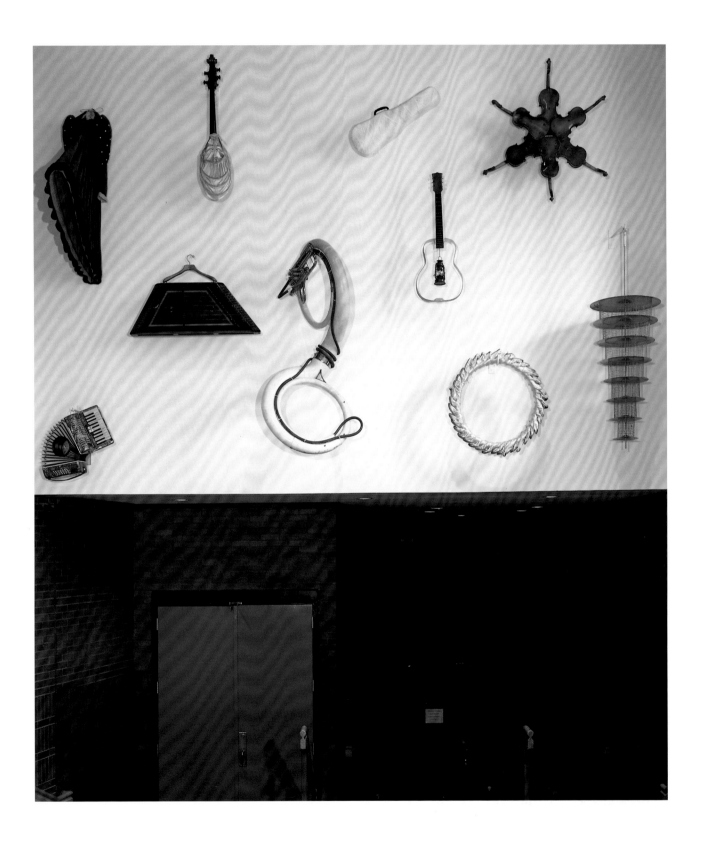

The LaGuardia Suite (detail; one of two panels), 1997, mixed media, dimensions variable, Collection of the New York City Board of Education

is like a battery charged with unused energy. In Lipski's world, much more than our own, materials do not grow obsolete with time; they retain transformative power as long as the viewer is willing to suspend disbelief.

Social anthropologist Michael Thompson, writing in *Rubbish Theory: The Creation and Destruction of Value*, posits three categories of objects capable of being possessed: valuable, valueless, and negatively valued.[35] In Thompson's theory of the nature of value, we understand worth by acknowledging what we discard. How we confer value then depends on the durability or transient nature of the object and on how we place the object within the context of our society and life so that "objects in the transient category decrease in value over time and have finite life spans. Objects in the durable category increase in value over time and have (ideally) infinite life spans."[36] Lipski turns Thompson's notion of value on its head. Just as our American culture of consumerism is sustained by a disposition toward abundance and disposability, rehabilitation of the discarded is pivotal to Lipski's ability to redefine notions of use and meaning. Making the transient visible, he makes it durable; recasting our presumptions of use, he allows us to revalue our notions of the material world.

Thompson's theory reinforces the Industrial Revolution perception of time as a product that can be charted in a straight line from its inception in manufacture to its end point in an act of discarding. But Lipski's art, like Alan Lightman's physics, mediates any singular definition of time with an ability to revalue the potential of any object. Lipski often chooses objects with codified and recognized societal values. Many are

associated with work, others with consumption, still others with desire. Nearly all are mass-produced. The ballet shoes in *Ballet Shoe Circle* (1997) (p. 60, 85) are emblematic of Thompson's theory: Dancers will cherish and nurture a special pair of ballet slippers long after they lose the better part of their utility.[37] They become beautiful to the dancer precisely because their disintegration reflects personal experience. They do not move easily from the durable to the transient because they possess a value that is inversely related to use.

Lipski is not the first artist to find inspiration in the manipulation of found objects, or joy in the material world of cast-off parts and odd lots of manufacturing components others would consider rubbish. His involvement with these cast-offs and his way of making art diverges from that of his forebears in the almost hedonistic approach he takes to things humans make and use, an approach that is decidedly anti-formal. Rather than the cool appropriations of Duchamp or the theoretical conceptualism of Robert Morris, Lipski is enthusiastically experimental and his art evinces a spirited optimism that is, at heart, the expression of a romantic world view. Drawn to objects he says he considers beautiful, Lipski admits that beauty is in the eye of the beholder. "Making things beautiful is pretty easy," he sums up. "But making things *really* beautiful is really hard."

Notes

1 Alan Lightman, *Einstein's Dreams,* (New York: Pantheon Books, 1993), 21.

2 All quotes by Donald Lipski, unless otherwise noted, are from an unpublished interview conducted by the author, July 17, 1999, Sagaponak, NY.

3 Unpublished interview with Donald Lipski conducted by the author, 1990, Brooklyn, NY.

4 *Einstein's Dreams,* 23.

5 Ibid., 68.

6 David S. Rubin, *Donald Lipski: Poetic Sculpture,* exhibition catalogue, Freedman Gallery, Albright College, Reading, PA, 1990, 4.

7 Jan Reilly, "Interview with Donald Lipski," in *The Bells,* exhibition catalogue, Cincinnati: The Contemporary Arts Center, 1991, np.

8 *Broken Wings: Donald Lipski at Grumman,* Hillwood Art Gallery, Long Island University-C.W. Post Campus. 1987, 18.

9 *Einstein's Dreams,* 38, 41.

10 Ibid., 13.

11 Albert Boime, "Waving the Red Flag and Reconstituting Old Glory," *Smithsonian Studies in American Art,* Spring 1990, 5.

12 *Star Spangled Banner,* Francis Scott Key, 1814.

13 Unpublished interview conducted by the author, September 1, 1990, New York.

14 Ibid.

15 Terrie Sultan, *Transgressions: Donald Lipski and Buzz Spector,* exhibition catalogue, Washington, DC: The Corcoran Gallery of Art, 1991, np.

16 The less familiar second verse of the *Star Spangled Banner,* Francis Scott Key, 1814, is:

> "On the shore dimly seen through the mists of the
> deep,
> Where the foe's haughty host in dread silence
> reposes,
> What is that which the breeze, o'er the towering
> steep,
> As it fitfully blows, half conceals, half discloses?
> Now it catches the gleam of the morning's first
> beam,
> In full glory reflected now shines in the stream.
> 'Tis the star-spangled banner, oh, long may it wave
> O'er the land of the free and the home of the
> brave!"

17 Joseph Wesley Zeigler, *Arts in Crisis: The National Endowment for the Arts Versus America,* (Chicago: a cappella books, 1994), 71.

18 *The Resonance of the Odd Object* was scheduled for 1990 and was to include Donald Lipski, Liz Larner, Patti Martori, Charles Ray, Zizi Raymond, and Buzz Spector. Later that year, Lipski and Spector agreed to present a two-person exhibition, *Transgressions,* in which Lipski presented works that addressed the issue of the American flag, while Spector focused on the psychology of eroticism.

19 *Who's Afraid of Red, White & Blue? #25* was installed at the Haviland Building of the University of the Arts in Philadelphia. *Black by Popular Demand* was created for the atrium at The Corcoran Gallery of Art, and is now in the Corcoran's permanent collection.

20 Elizabeth Hess, "Capture the Flag: Rescuing (and Destroying) Old Glory at C.W. Post," *The Village Voice,* February 20, 1996, 77.

21 Jack Sirica, "No Longer a Museum Piece?" *Newsday,* Tuesday, January 23, 1996.

22 *Einstein's Dreams,* 115.

23 Marjorie Welish, *Donald Lipski: Waxmusic and Candelabracadabra,* exhibition catalogue, New York: Galerie Lelong, 1992, 4.

24 *Oral History* was presented at the Southeastern Center for Contemporary Art in 1994 as part of an "Artist in the Community," a residency program in which artists worked with members of the local community to create projects that focused on the Winston-Salem area.

25 *Bricolage* (French) noun, masculine; do-it-yourself; makeshift repair.

26 *Assemblage* (French) noun, masculine; putting together, mixture.

27 Michael Crichton, *Jasper Johns,* exhibition catalogue, New York: Harry N. Abrams, Inc. in association with the Whitney Museum of American Art, 1977, 21.

28 *Einstein's Dreams,* 70.

29 Robert Smithson, "Quasi-Infinities and the Waning of Space" in *The Writings of Robert Smithson,* Nancy Holt, ed. (New York: New York University Press, 1979), 33.

30 *Einstein's Dreams,* 123.

31 *Exquisite Copse,* Galerie Lelong, New York, NY, 2000.

32 *Einstein's Dreams,* 133.

33 Vincent P. Smedile, "Entertainment Best Bets," *Newsday,* May 23, 1993.

34 Brooke Kamin Rapaport, "Interview with Donald Lipski" in *Pieces of String Too Short to Save,* exhibition brochure, Brooklyn Museum of Art, 1993, np.

35 Michael Thompson, *Rubbish Theory: The Creation and Destruction of Value,* (Oxford, New York, Toronto, Melbourne: Oxford University Press, 1979), 2.

36 Ibid., 7.

37 The ballet shoes in *Ballet Shoe Circle* were used by dancers of the New York City Ballet during their 1997 season.

Works in the Exhibition

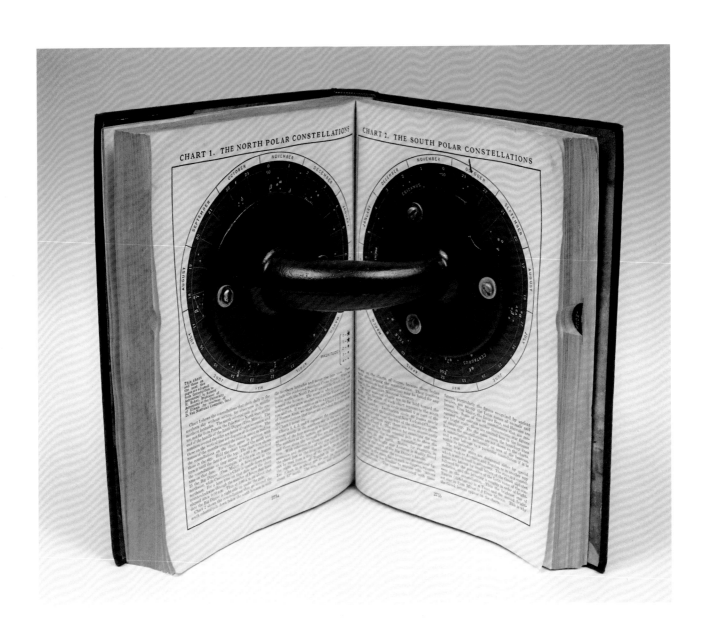

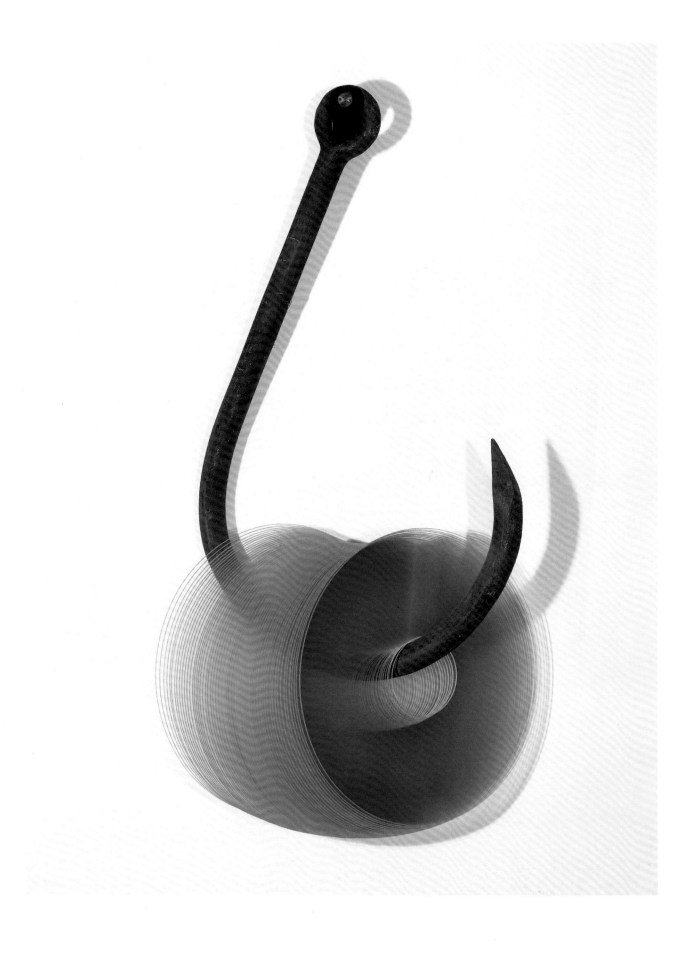

66 *Untitled #126, 1987*

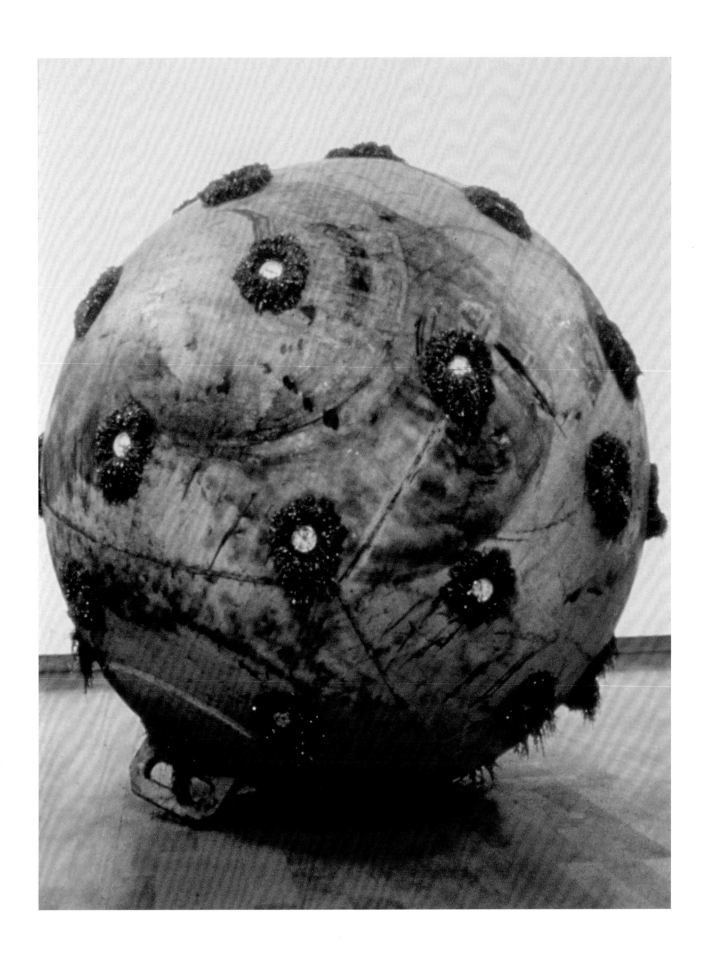

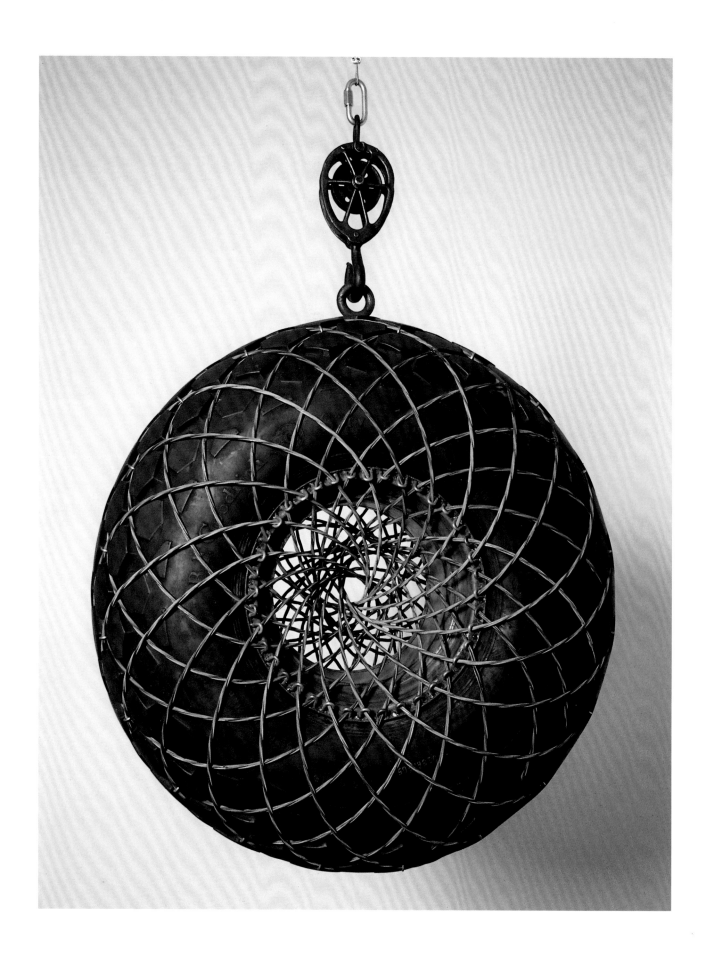

68 *Untitled #89-50*, 1989

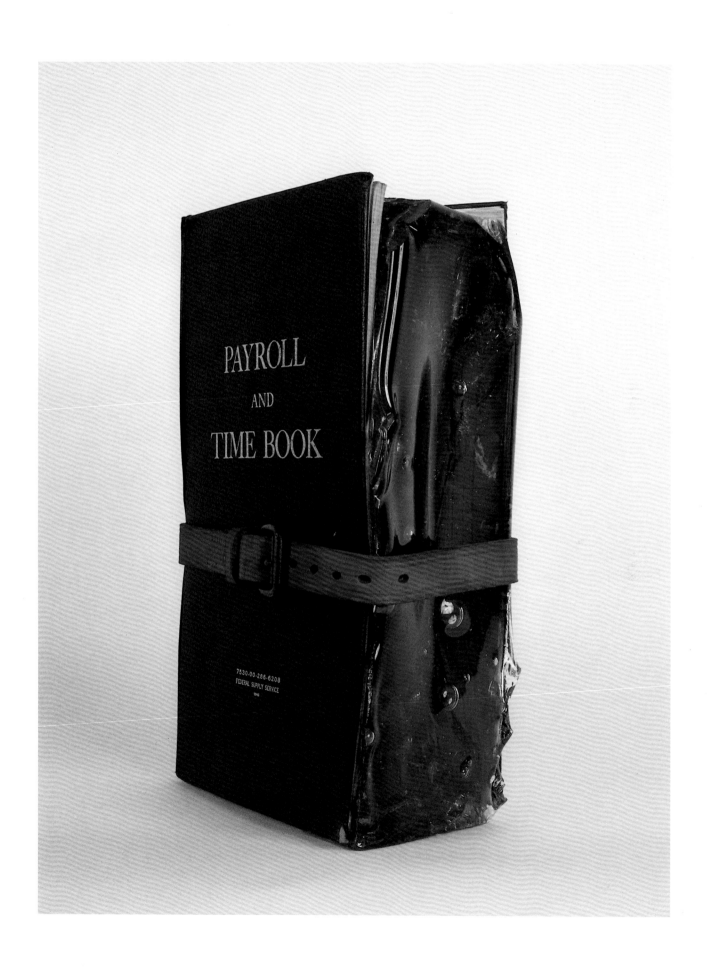

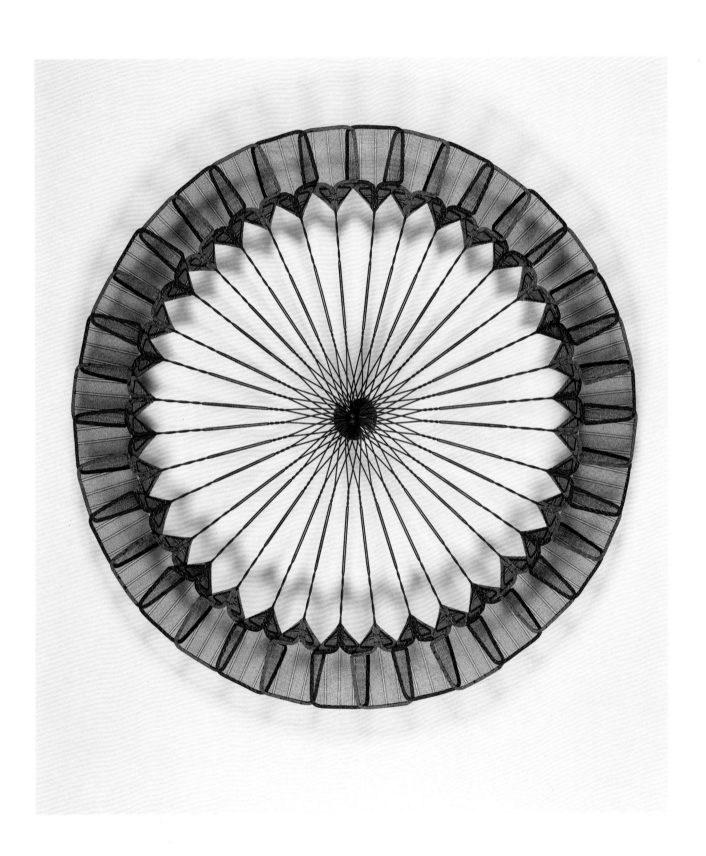

Untitled #90-07, 1990

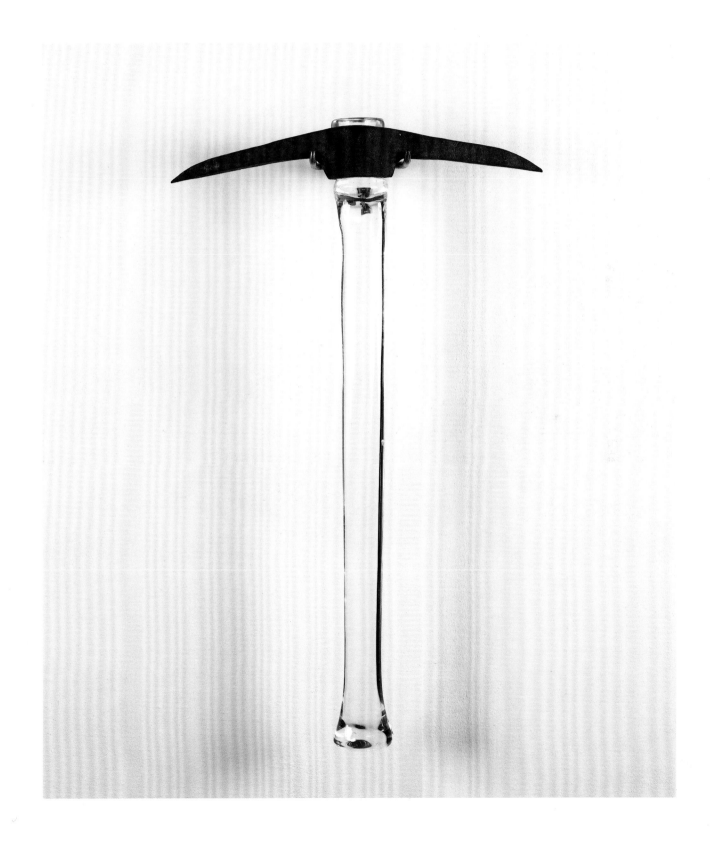

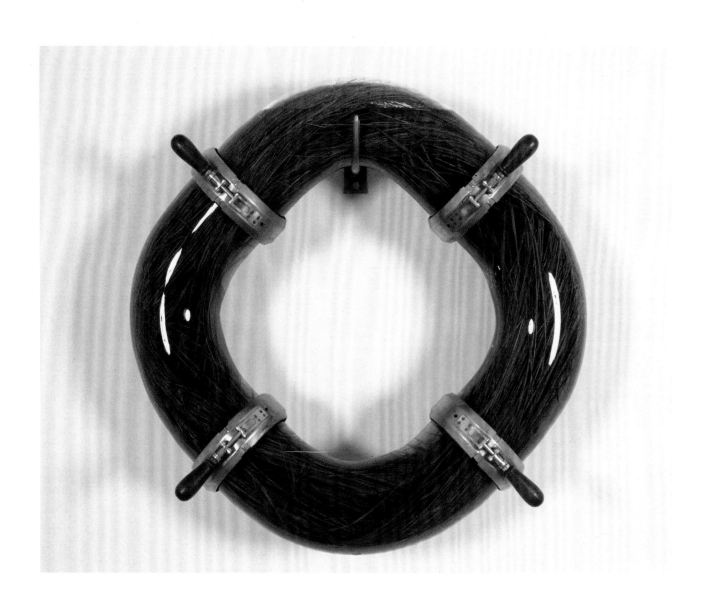

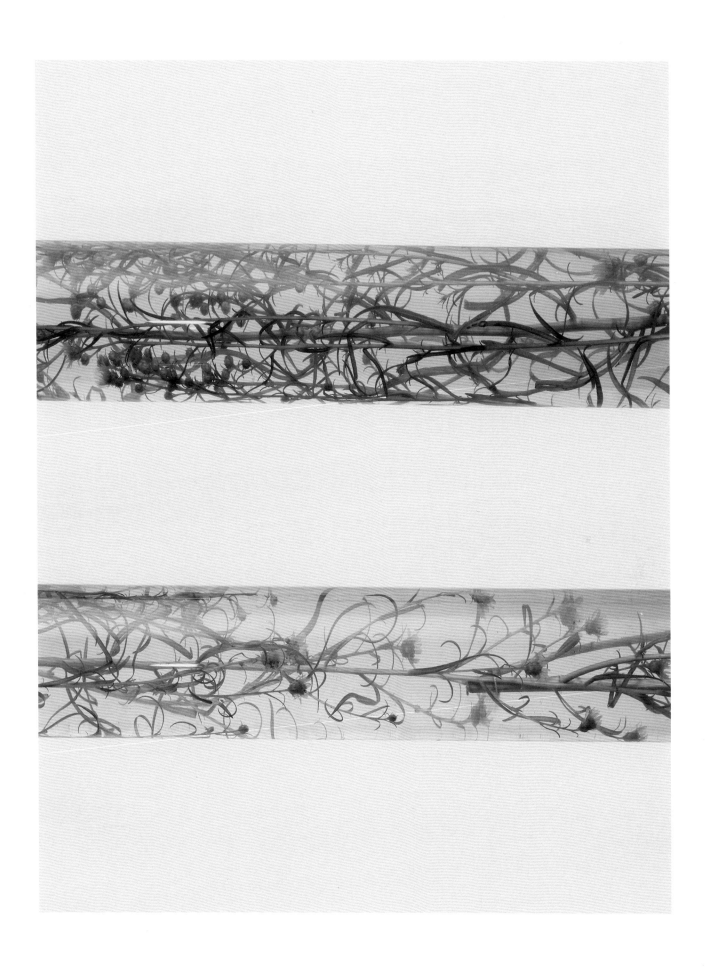

Water Lilies #58, 1990 (detail) 73

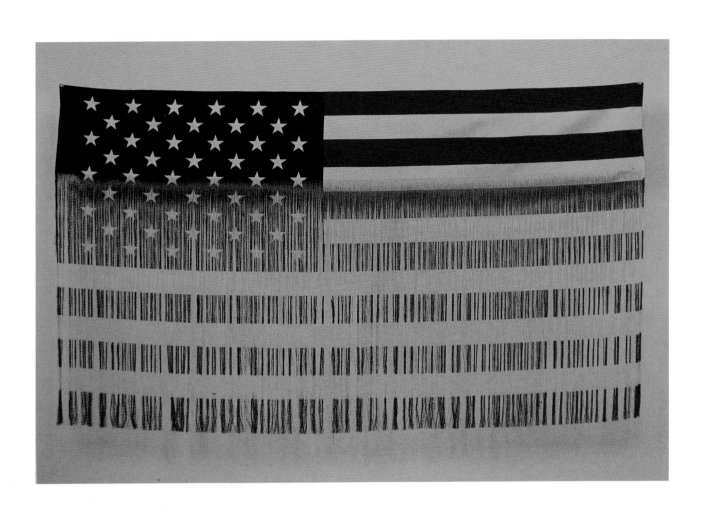

Who's Afraid of Red, White & Blue? #8, 1990

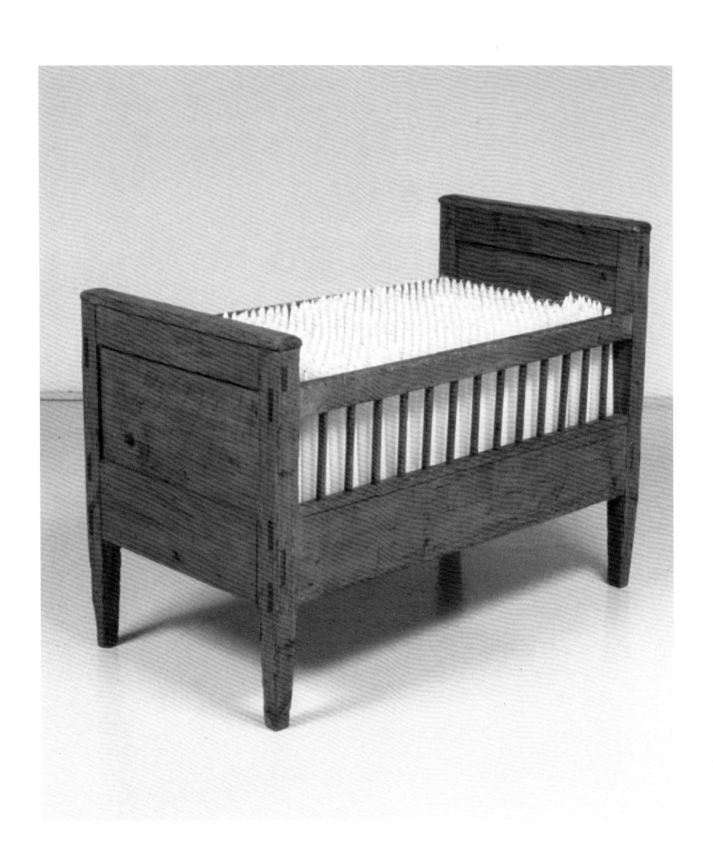

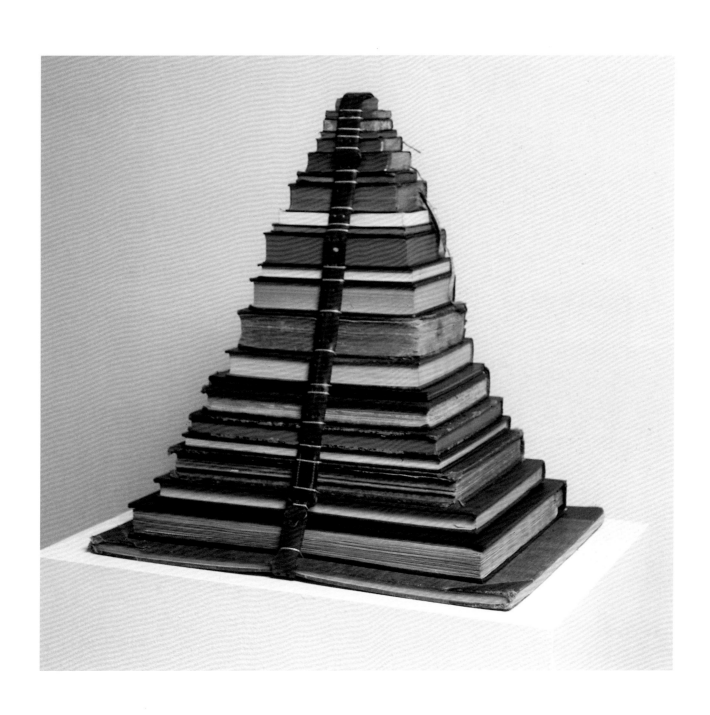

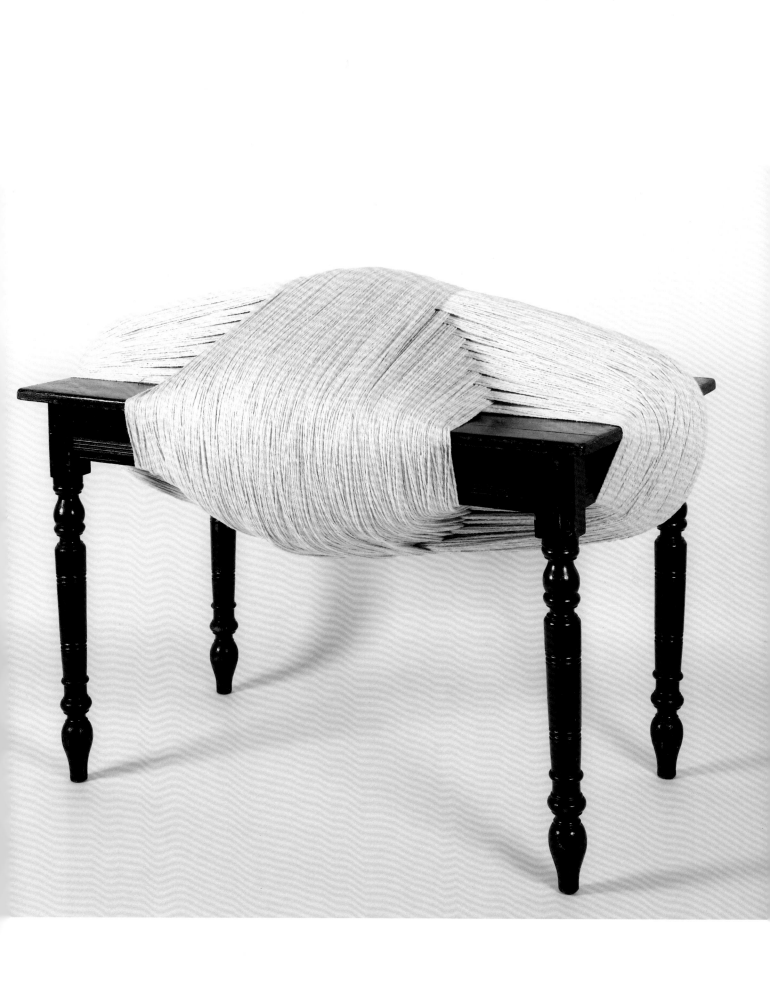

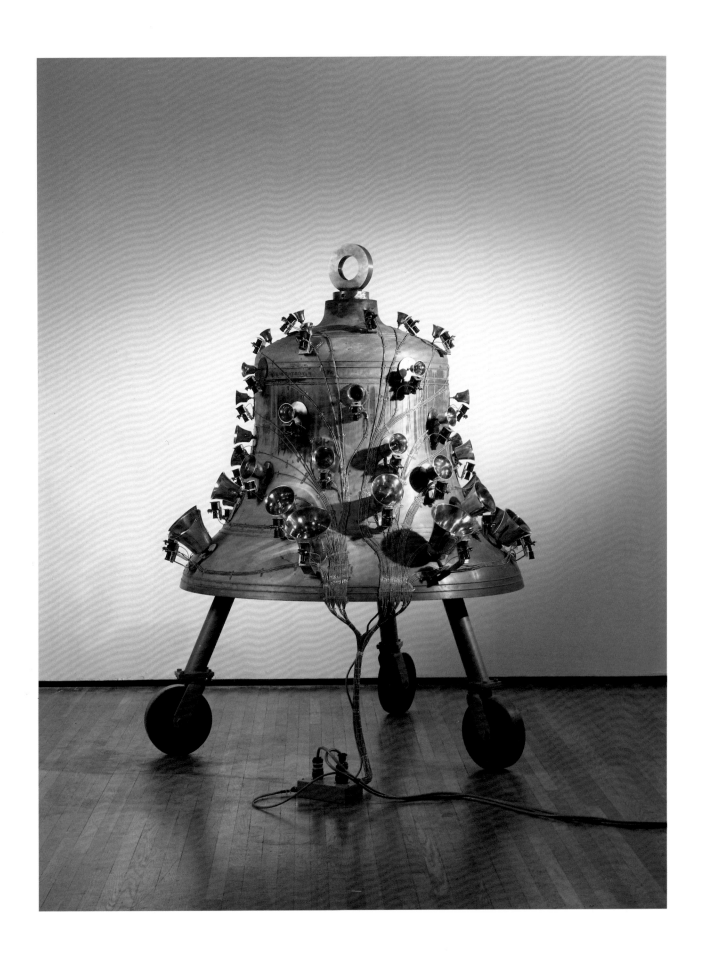

In Memory of Silent Deeds, 1991

Texas Instruments, 1992 (detail) 79

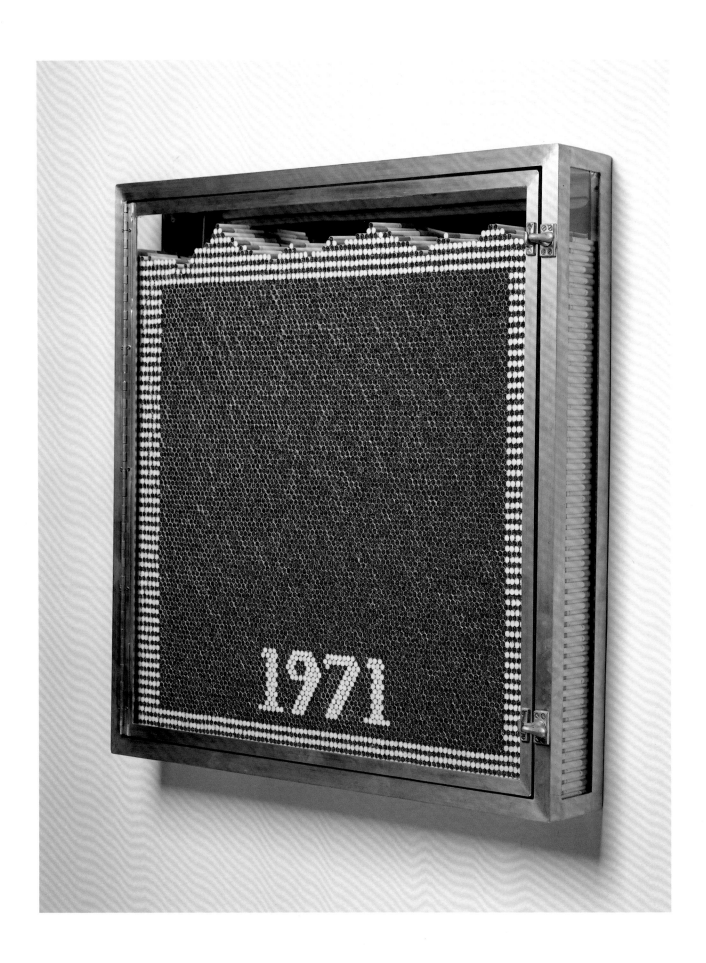

82 Maquette for *The Yearling*, 1993 (being examined by the artist's son)

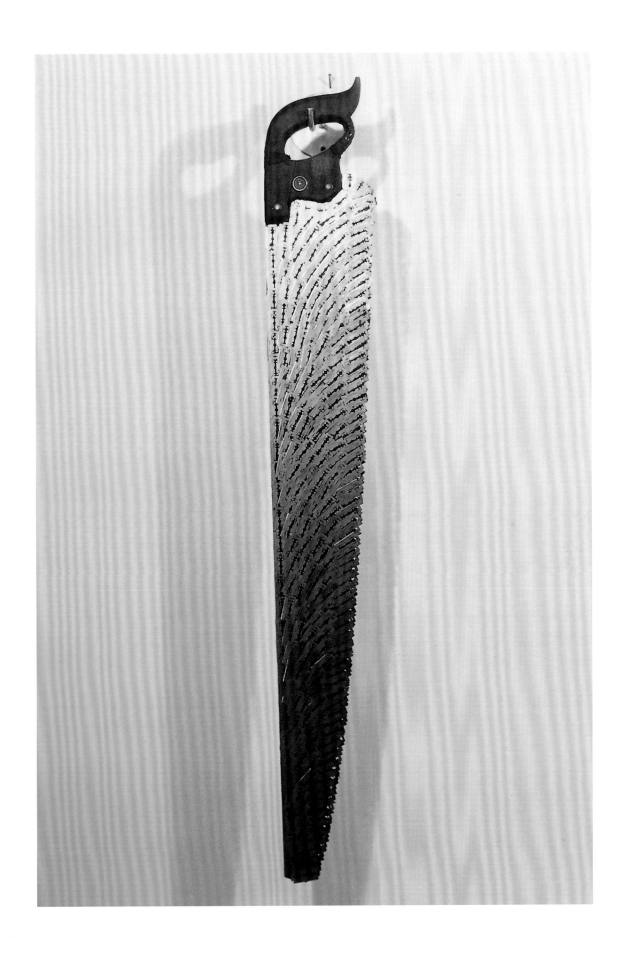

84 *The Starry Night* (detail), 1994

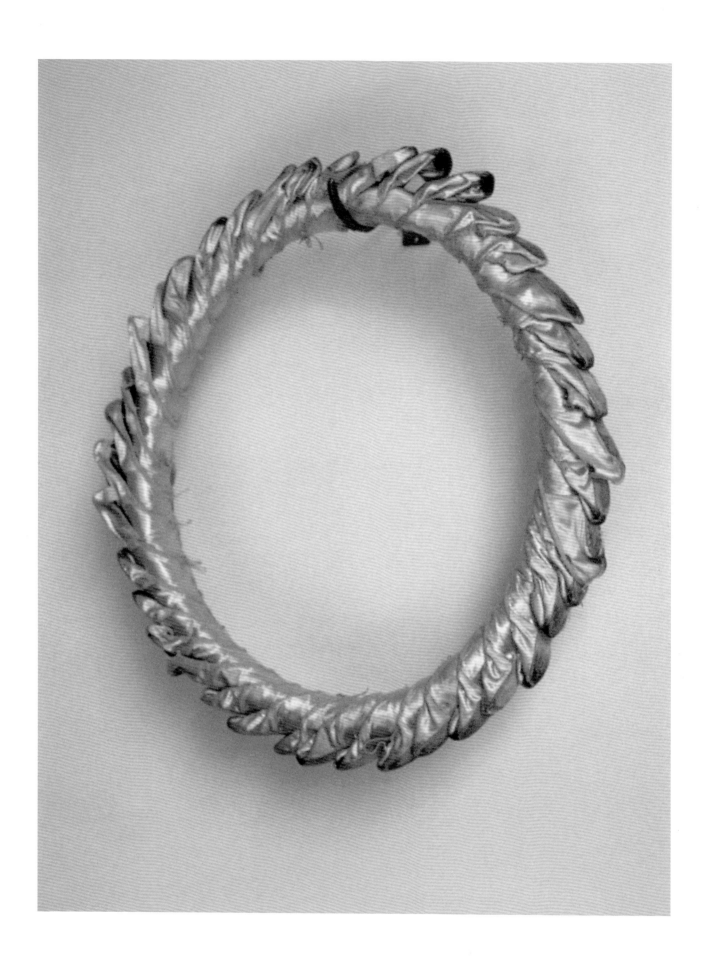

Ballet Shoe Circle, from *The LaGuardia Suite,* 1997 85

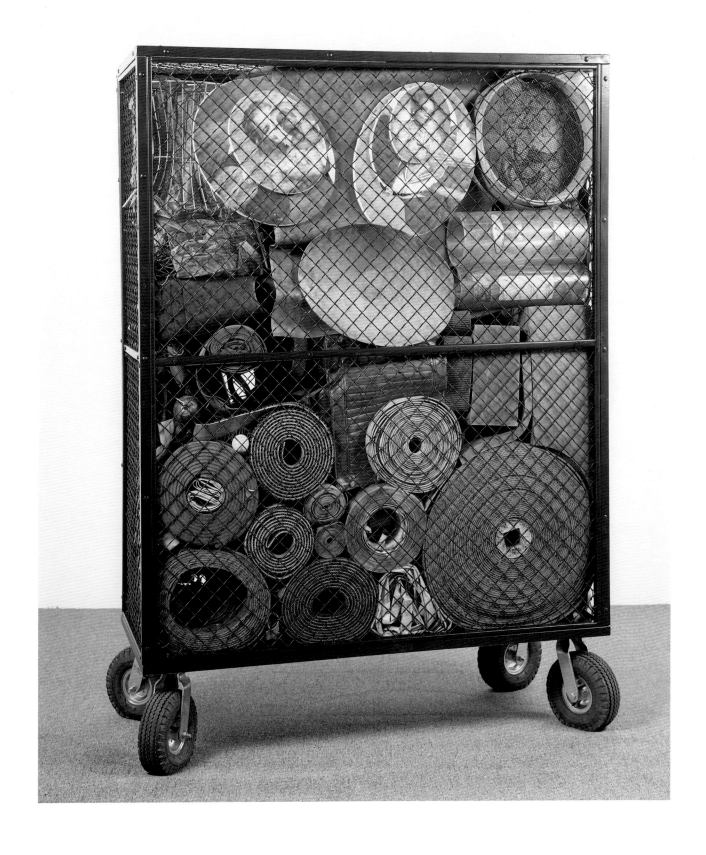

Pieces of String Too Short to Save, 1998 (one of twelve elements)

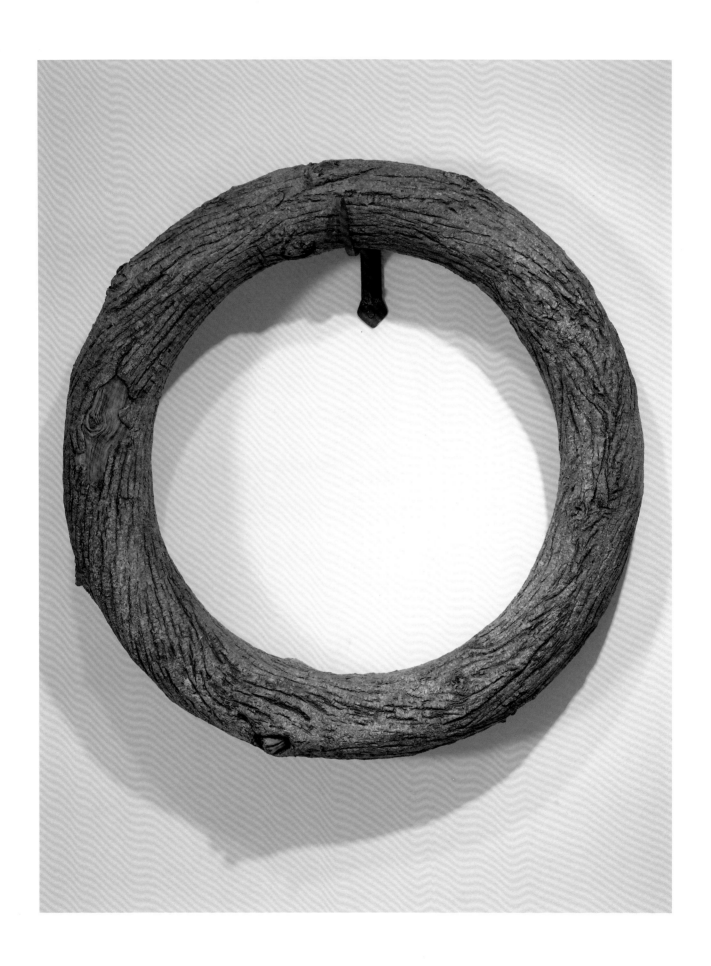

Exquisite Copse No. 6 (First Ring), 2000 87

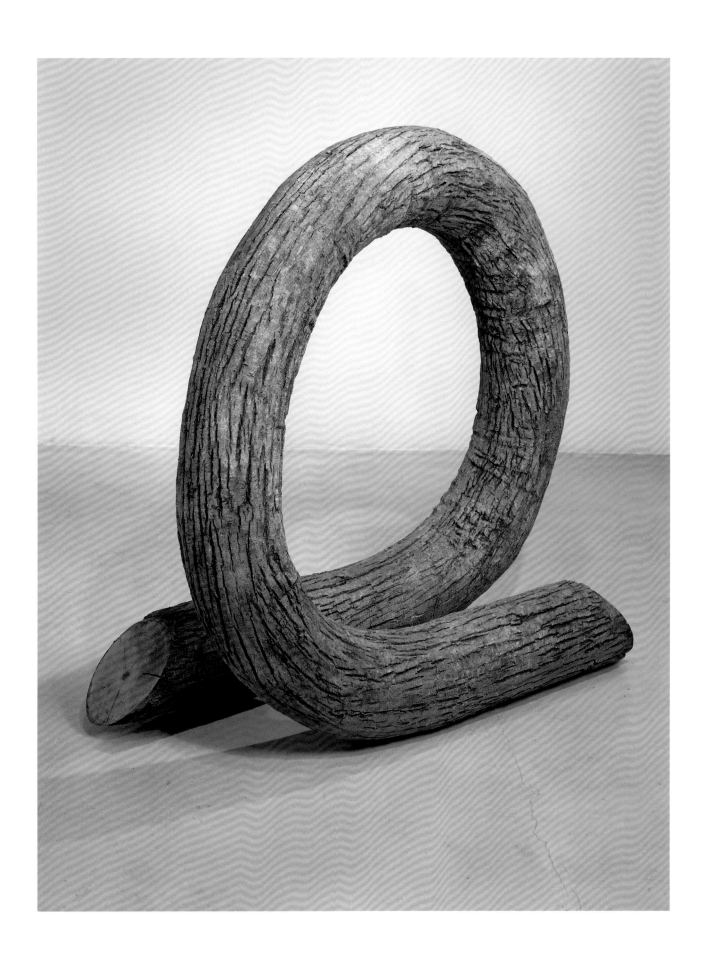

88 *Exquisite Copse No. 17 (First Loop),* 2000

Exhibition Checklist

Dimensions are in inches. Height precedes width precedes depth.

1. *Building Steam #105*, 1983
 paper, steel, cloth
 10¼ x 11⅜ x 6
 The Patsy R. and Raymond D. Nasher Collection, Dallas, Texas

2. *Untitled #126*, 1987
 steel, glass, rubber, nickel
 36 x 19 x 10
 Collection of Frederick R. Weisman Art Museum, University of Minnesota, gift of Mike and Penny Winton

3. *The North*, 1988 †
 mixed media
 58 diameter
 Collection of Terri Hyland
 Courtesy of Laumeier Sculpture Park

4. *Untitled #89-50*, 1989
 mixed media
 61 x 41 x 20
 Courtesy of the artist and Carl Solway Gallery, Cincinnati, Ohio

5. *Pilchuck #90-14*, 1990
 paper, glass, leather
 14 x 9½ x 4
 Collection of Reva and Philip Shovers

6. *Untitled #90-07*, 1990
 steel, cotton
 44½ x 44½ x 6½
 Collection of Janis and William Wetsman

7. *Untitled #90-11*, 1990
 steel, glass
 33 x 20 x 3½
 Hot glass formed by Paul DeSoma
 Collection of Dudley and Michael Del Balso

8. *Water Lilies #35*, 1990
 glass, dune grass, preservative solution, steel, wood
 32 x 32 x 13
 Collection of Museum of Contemporary Art, San Diego, Museum Purchase, Contemporary Collectors Fund

9. *Water Lilies #58*, 1990
 glass, herbs, preservative solution, steel
 8 x 132 x 2
 Collection of The Detroit Institute of Arts, Founders Society Purchase, W. Hawkins Ferry Fund, Andrew L. and Gayle Shaw Camden Sculpture and Decorative Arts Fund, and Mary Moore Denison Modern Art Fund

10. *Who's Afraid of Red, White & Blue? #8*, 1990
 nylon
 36 x 60
 Courtesy of the artist and Galerie Lelong

11. *Untitled*, 1991
 wax, wood
 29½ x 44½ x 24
 Courtesy of the artist and Hill Gallery, Birmingham, Michigan

12. *Untitled #91-001*, 1991
 paper, leather
 24 x 23¼ x 17½
 Collection of Gayle and Andrew Camden, Detroit, Michigan

13. *Untitled #91-08*, 1991
 cotton, wood
 39 x 55 x 36
 Courtesy of the artist and Galerie Lelong

14. *In Memory of Silent Deeds*, 1991
 bronze, mixed media
 92 x 62 x 62
 Courtesy of the artist and The Verdin Company

15. *Texas Instruments*, 1992 †
 mixed media
 168 x 240
 Courtesy of the artist and Galerie Lelong

16. *Untitled, 1992*
 wood, steel wool
 48 x 7 x 1$^1/_2$
 Courtesy of the artist and Galerie Lelong

17. *The Humidors 1961–1990, 1993*
 (three of thirty elements)
 cigarettes, tobacco leaves, aluminum, plexiglass
 32$^1/_4$ x 32$^1/_4$ x 4$^3/_4$
 Courtesy of the artist and Galerie Lelong

18. Maquette for *The Yearling*, 1993
 wood, plastic
 20 x 10 x 10
 Collection of Jackson Hyland-Lipski

19. *Untitled #94-06, 1994*
 steel, wood, tar
 48 x 6 x 1
 Courtesy of the artist and
 Rhona Hoffman Gallery, Chicago

20. *The Starry Night*, 1994 †
 steel
 dimensions variable
 Collection of the artist

21. *Ballet Shoe Circle,* 1997
 (from *The LaGuardia Suite*)
 satin, leather, cotton, nylon, steel
 36 diameter
 Collection of the New York City Board of
 Education

22. *Pieces of String Too Short to Save, 1998*
 (one of twelve elements)
 mixed media
 80 x 60 x 24
 Courtesy of the artist and Carl Solway Gallery,
 Cincinnati, Ohio

23. *Exquisite Copse No. 6 (First Ring),* 2000
 mixed media
 41 diameter
 The West Family Collection at SEI

24. *Exquisite Copse No. 17 (First Loop),* 2000
 mixed media
 46$^1/_2$ x 21 x 46
 Courtesy of the artist and Galerie Lelong

† Recreated for the exhibition, *Donald Lipski: A Brief History of Twine.*

Chronology

1947	Born in Chicago, Illinois.
1970	Receives BA in History, University of Wisconsin-Madison.
1971–77	Marriage to Dorothy Zeidman.
1973	Receives MFA in Ceramics, Cranbrook Academy of Art, Bloomfield Hills, Michigan.
1973–77	Teaches at University of Oklahoma at Norman.
1974	Creates *Gathering Dust* in a group sculpture exhibition, *Non-Coast Flatland Sculpture,* at the Wichita Art Museum, Wichita, Kansas.
1977	Moves to New York, New York.
1978	*Gathering Dust* is exhibited at Artists Space in New York, New York, to much acclaim; three months later, the installation is presented at The Museum of Modern Art, New York.
	Travels to Bulgaria to exhibit at *The Artist At Work In America.*
	Receives a National Endowment for the Arts award.

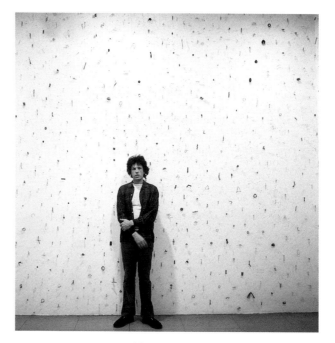

Donald Lipski and *Gathering Dust,* 1979,
The Museum of Modern Art, New York

1980	Over the next two years, works on *Passing Time* sculpture series, which travels in the United States and abroad.
1981	Rents the former Astor Tool and Die building for his studio in Greenpoint, Brooklyn.
1982	Creates the *Building Steam* series.
1984	Receives a second National Endowment for the Arts award.
1986	In collaboration with Grumman Corporation, Long Island, New York, an aerospace manufacturer, exhibits *Broken Wings: Donald Lipski at Grumman* at the Hillwood Art Gallery at Long Island University.
	Receives the New York Foundation for the Arts Fellowship.
1987	Father dies.
	First incorporates the American flag into *The Ether.*
1988	Receives a Guggenheim Fellowship.

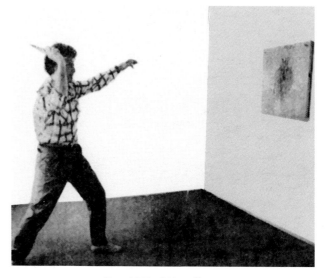

Donald Lipski installing *Passing Time No. 225,* 1980–81, at Anders Tornberg Gallery, Lund, Sweden

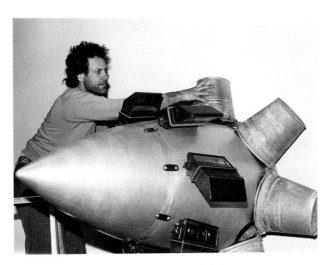

Donald Lipski installing *Broken Wings #3*, 1986, pod housing, buckets, periscopes, hardware, 43 x 46 x 52 inches, Collection of Phoenix Art Museum

1989 Marries Terri Hyland.

Along with five other artists, withdraws from a group exhibition, *The Resonance of the Odd Object*, scheduled for 1990 at The Corcoran Gallery of Art in Washington, DC, in response to the museum's cancellation of *Robert Mapplethorpe: The Perfect Moment*.

Buys a cottage in Amagansett, New York.

1990 Terrie Sultan curates a two-person exhibition of work by Lipski and Buzz Spector, entitled *Transgressions*, at The Corcoran Gallery of Art in Washington, DC; Lipski presents sculptures that incorporate and address the American flag.

Completes a project with The Fabric Workshop in Philadelphia, Pennsylvania, creating the American flag series, *Who's Afraid of Red, White & Blue?*

Serves as artist-in-residence at the Pilchuck Glass School in Stanwood, Washington.

Continuing to work with glass, juxtaposes glass tubing with plant material in the *Water Lilies* series, shown at the Lennon/Weinberg Gallery in New York, New York.

Receives his third National Endowment for the Arts award.

1991 Creates a series of *Untitled* pieces that incorporate candles with everyday objects.

Work featured in the *Whitney Biennial*.

Invited by The Contemporary Arts Center in Cincinnati, Ohio, to create a new body of work in collaboration with a local industry. Lipski chooses The Verdin Company, the oldest and largest bell manufacturer in the United States. The exhibition, entitled *The Bells*, presents four of Lipski's bell works, *The Belles, Leaves of Grass, In Memory of Silent Deeds,* and *Der Kleiner Bells.*

1992 Installation of *The Yearling*, a work commissioned by the New York City Board of Education, Public Art for Public Schools program, is cancelled due to controversy.

Jackson Hyland-Lipski is born.

Closes his Greenpoint studio in Brooklyn and spends the year in Houston, Texas.

1993 Spends the year in San Francisco, California.

Installs *Pieces of String Too Short to Save* in the Grand Lobby of the Brooklyn Museum of Art, New York; the work consists of truckloads of objects Lipski has collected over the years.

Receives an Academy Award from the American Academy and Institute of Arts and Letters.

1994 *The Starry Night* is created for the Capp Street Project in San Francisco, California.

As part of a 1993 residency at the Southeastern Center for Contemporary Art in Winston-Salem, North Carolina, Lipski completes *The Humidors* and *Tobaccolage* for his exhibition, *Oral History*.

Moves to Sag Harbor, New York.

1996 Installs a large-scale work, *The Cauldron*, composed of reconfigured trees, at The Parrish Art Museum in Southampton, New York.

In conjunction with the Public Art for Public Schools program the New York City Board of Education commissions *The LaGuardia Suite*.

1997 Installs *The LaGuardia Suite* at the LaGuardia High School of Music & Art and Performing Arts, New York, New York.

The State University of New York in Purchase, New York, commissions the work *Sallie*.

Installs *The Yearling* at the Doris Friedman Plaza, Scholar's Gate, at the southeast entrance to Central Park.

1999 Permanently installs *The Yearling* at the Denver Public Library in Denver, Colorado.

Creates the monumental *Sirshasana,* a public artwork for the entrance to the Grand Central Market at Grand Central Terminal, New York, New York.

Jackson Hyland-Lipski with *Rodin Rodinadanna,* 2000, Avenue of the Arts, Kansas City, Missouri

Donald Lipski at Wānas Castle, Sweden, 1992

2000	Exhibits the *Exquisite Copse* series at Galerie Lelong, New York, New York.
	Madison Art Center, Madison, Wisconsin, organizes *Donald Lipski: A Brief History of Twine,* a comprehensive survey of the artist's work; the exhibition travels to the Blaffer Gallery, The Art Museum at the University of Houston, Texas.
	Receives the Rome Prize from the American Academy in Rome, Italy.
	Creates *Rodin Rodinadanna* for Avenue of the Arts, Kansas City, Missouri.
2000–01	Spends a year at the American Academy in Rome, Italy.

Biography

EDUCATION

1970 BA in History, University of Wisconsin-Madison

1973 MFA in Ceramics, Cranbrook Academy of Art, Bloomfield Hills, Michigan

AWARDS

1978 National Endowment for the Arts

1984 National Endowment for the Arts

1986 New York Foundation for the Arts Fellowship

1988 Guggenheim Fellowship

1990 National Endowment for the Arts

1993 Academy Award, American Academy and Institute of Arts and Letters

2000 Rome Prize, American Academy in Rome, Italy

PUBLIC COMMISSIONS

1994 *Ball? Ball! Wall? Wall!*, Commission for Laumeier Sculpture Park

1996 *The LaGuardia Suite*, Commission for the New York City Board of Education, installed at LaGuardia High School of Music & Art and Performing Arts, New York, New York

1997 Commission for State University of New York, Purchase, New York

Consultant to Brookhaven National Laboratory, New York

1997–98

The Yearling, installation at the Doris Friedman Plaza, Scholar's Gate, southeast entrance to Central Park, sponsored by the Public Art Fund, New York, New York

1999 *The Yearling*, permanent installation at the Denver Public Library, Denver, Colorado

Sirshasana, Arts for Transit commission for permanent installation at Grand Central Market at Grand Central Terminal, New York, New York

2000 *Rodin Rodinadanna* installation for Avenue of the Arts, Kansas City, Missouri, June 2000

SOLO EXHIBITIONS

1974 Contemporary Arts Foundation, Oklahoma City, Oklahoma

1975 Everson Museum of Art, Syracuse, New York

1976 Macalaster Galleries, Saint Paul, Minnesota

1977 *Gathering Dust*, Delahunty Gallery, Dallas, Texas

1978 *Gathering Dust*, Artists Space, New York, New York

Anthology Film Archives, New York, New York

1979 *Gathering Dust*, The Museum of Modern Art, New York, New York

Anthology Film Archives, New York, New York

1980 *Gathering Dust*, Modern Art Museum of Fort Worth, Fort Worth, Texas

Pittsburgh Center for the Arts, Pittsburgh, Pennsylvania

1981 *Gathering Dust*, Tangeman Fine Arts Gallery, University of Cincinnati, Ohio

Passing Time, Braathen-Gallozzi Gallery, New York, New York

Triton Museum of Art, Santa Clara, California

1982 *Passing Time*, Portland Center for the Visual Arts, Portland, Oregon

1983 *Building Steam*, Germans Van Eck Gallery, New York, New York

Anders Tornberg Gallery, Lund, Sweden

1984 *Building Steam*, Rhona Hoffman Gallery, Chicago, Illinois

Building Steam, Margo Leavin Gallery, Los Angeles, California

P.B. van Voorst van Beest Gallery, The Hague, Netherlands

1985 *Piecemaker*, University of Delaware, University Gallery, Newark, Delaware

New Orleans Museum of Contemporary Art, New Orleans, Louisiana

Germans Van Eck Gallery, New York, New York

Carpenter & Hochman Gallery, Dallas, Texas

1986 Rhona Hoffman Gallery, Chicago, Illinois

Edward Totah Gallery, London, England

1987 Dorothy Goldeen Gallery, Santa Monica, California

Galerie Pierre Huber, Geneva, Switzerland

Center on Contemporary Art, in cooperation with Boeing International, Seattle, Washington

Anders Tornberg Gallery, Lund, Sweden

Broken Wings, Hillwood Art Gallery, C.W. Post College, Long Island University, Brookville, New York

Germans Van Eck Gallery, New York, New York

1988 Rhona Hoffman Gallery, Chicago, Illinois

Germans Van Eck Gallery, New York, New York

1989 Dorothy Goldeen Gallery, Santa Monica, California

Danforth Museum of Art, Framingham, Massachusetts

1990 Davis/McClain Gallery, Houston, Texas

Evanston Art Center, Evanston, Illinois

Donald Lipski: Poetic Sculpture, Freedman Gallery, Albright College, Reading, Pennsylvania; traveled to University Galleries, Normal, Illinois; Otis Art Institute of the Parsons School of Design, Los Angeles, California; Honolulu Academy of Arts, Honolulu, Hawaii; Hudson River Museum, Yonkers, New York; Cleveland Center for Contemporary Art, Cleveland, Ohio

Water Lilies, Lennon/Weinberg Gallery, New York, New York

Paul Kasmin Gallery, New York, New York

Who's Afraid of Red, White & Blue?, The Fabric Workshop, The Philadelphia College of Art, Philadelphia, Pennsylvania; Beaver College, Glenside, Pennsylvania; and The Corcoran Gallery of Art, Washington, DC

Lorence Monk Gallery, New York, New York

1991 *Donald Lipski: Glass*, Robert Lehman Gallery, New York Experimental Glass Workshop, Brooklyn, New York

Rhona Hoffman Gallery, Chicago, Illinois

The Bells, The Contemporary Arts Center, Cincinnati, Ohio; traveled to the Museum of Contemporary Art, Chicago, Illinois; P.S.1, Long Island City, New York

Carl Solway Gallery, Cincinnati, Ohio

Anselmo Alvarez Galerie de Arte, Madrid, Spain

Davis/McClain, Houston, Texas

1992 Galerie Lelong, New York, New York

Anders Tornberg, Lund, Sweden

Americas, Monasterio de Santa Clara, Moguer (Huelva)

1993 *The Texas Works*, Davis/McClain Gallery, Houston, Texas

Wave, installation, Allen Center Gallery, Houston, Texas

Pieces of String Too Short to Save, Grand Lobby Installation, Brooklyn Museum of Art, Brooklyn, New York

The Texas Works, Dorothy Goldeen Gallery, Santa Monica, California

Donald Lipski, Johnson Community College, Overland Park, Kansas

1994 *Oral History*, Southeastern Center for Contemporary Art, Winston-Salem, North Carolina

Donald Lipski: Sculpture, Hill Gallery, Birmingham, Michigan

Donald Lipski: Wall Works, Galerie Lelong, New York, New York

The Starry Night, Capp Street Project, San Francisco, California

1995 *Donald Lipski*, Galerie Lelong, Paris, France

Donald Lipski, Galleria Il Ponte, Roma, Italy

Donald Lipski, Peiro Cavellini, Brescia, Italy

Donald Lipski: The Humidors, Laumeier Sculpture Park, Saint Louis, Missouri

Donald Lipski, John Berggruen Gallery, San Francisco, California

1996 *The Cauldron: An Installation by Donald Lipski*, The Parrish Art Museum, Southampton, New York

1997 *Donald Lipski: Pond Life*, Ambrosino Gallery, Miami, Florida

The LaGuardia Suite, LaGuardia High School of Music & Art and Performing Arts, New York, New York

Donald Lipski: The Yearling, temporary installation at the southeast entrance to Central Park, The Public Art Fund of New York, New York

Donald Lipski: Sculpture, Cohen Berkowitz Gallery for Contemporary Art, Kansas City, Missouri

1998 *Donald Lipski, Book Works, 1982–1997*, John Gibson Gallery, New York, New York; Hill Gallery, Birmingham, Michigan; Barbara Davis Gallery, Houston, Texas

1999 *Donald Lipski*, Bawag Foundation, Vienna, Austria

2000 *Exquisite Copse*, Galerie Lelong, New York, New York

Donald Lipski: Selected Works from Passing Time and Building Steam, 1980–1985, John Gibson Gallery, New York, New York

Donald Lipski: A Brief History of Twine, Madison Art Center, Madison, Wisconsin; travels to the Blaffer Gallery, The Art Museum of the University of Houston, Houston, Texas

SELECTED GROUP EXHIBITIONS

1974 *Non-Coast Flatland Sculpture,* Wichita Art Museum, Wichita, Kansas

1977 *X International Encounter on Video,* Tokyo, Japan

1978 *XI International Encounter on Video,* Tokyo, Japan

Atlanta Film Festival, High Museum of Art, Atlanta, Georgia

1979 *Notations,* Cornish Institute, Seattle, Washington

Diamond, Lieberman, Lipski, Root Art Center, Clinton, New York

Videotapes and Drawings, Hunter College Art Gallery, New York, New York

1980 *The Artist at Work in America,* Varna, Bulgaria, Organized by the International Communications Agency, United States State Department

1981 *Seven Artists,* Neuberger Museum, State University of New York at Purchase, Purchase, New York

Stay Tuned, New Museum of Contemporary Art, New York, New York

Art on the Beach, Creative Time, Inc., New York, New York

Braathen/Gallozzi Gallery, New York, New York

1982 *15 Artists,* Cranbrook Art Museum, Bloomfield Hills, Michigan

1983 Grace Borgenicht Gallery, New York, New York

Black and White, Margo Leavin Gallery, Los Angeles, California

Language, Drama, Source and Vision, New Museum of Contemporary Art, New York, New York

Awards Exhibition, The American Academy and Institute of Arts & Letters, New York, New York

1984 *Twelve on 20 x 24,* School of the Museum of Fine Arts, Boston, Massachusetts

The End of the World, New Museum of Contemporary Art, New York, New York

American Sculpture, Margo Leavin Gallery, Los Angeles, California

Svart pa Vitt, Galleriet, Lund, Sweden

Awards in the Visual Arts 3, San Antonio Museum of Art, San Antonio, Texas; traveled to Loch Haven Art Center, Loch Haven, Florida; Cranbrook Art Museum, Bloomfield Hills, Michigan

Premio Internacional de Escultura, Museo Orensanz y Artes del Serrable, Spain

Site Sculptures, Herron Gallery, Herron School of Art, Indiana University-Purdue University, Indianapolis, Indiana

Varieties of Sculptural Ideas, Max Hutchinson Gallery, New York, New York

1985 *Wolfgang Amadeus Mozart-Neue Bilder,* Galerie Thaddaeus Ropac, Salzburg, Austria

Burnett Miller Gallery, Los Angeles, California

Working in Brooklyn/Sculpture, Brooklyn Museum of Art, Brooklyn, New York

Selections from the Collection of William J. Hokin, Museum of Contemporary Art, Chicago, Illinois

Herron Gallery, Herron School of Art, Indiana University-Purdue University, Indianapolis, Indiana

Abstract Relationships, Charles Cowles Gallery, New York, New York

State of the Art, Twining Gallery, New York, New York

1986 *Joseph Cornell and His Legacy: Part II,* A.C.A. Galleries, New York, New York

Formes et Couleurs, Galerie Pierre Huber, Geneva, Switzerland

Perfo-4D, Lantaren/Venster, Rotterdam, Netherlands

Donald Baechler, Richard Bosman, Donald Lipski, Galerie Montenay-Desol, Paris, France

Donald Lipski, Matt Mullican, Kiki Smith, The Clocktower, New York, New York

Small Monuments, Temple Gallery, Tyler School of Art of Temple University, Philadelphia, Pennsylvania

Surrealismo, Barbara Brathen Gallery, New York, New York

1987 *American Sculpture: Investigations,* Davis/McClain Gallery, Houston, Texas

Esprit, Salama Caro Gallery, London, England

1988 *Alter Alter,* Carlo Lamagna Gallery, New York, New York

Sculpture/Aspen 88, Aspen Art Museum, Aspen, Colorado

Sculpture Inside Outside, Walker Art Center, Minneapolis, Minnesota; traveled to The Museum of Fine Arts, Houston, Texas

The Objects of Sculpture, The Arts Club of Chicago, Chicago, Illinois

Seeing Glass, Snug Harbor Cultural Center, Inc., Staten Island, New York

Forecasts, Nerlino Galery, Inc., New York, New York

Rhona Hoffman Gallery, Chicago, Illinois

1988 *L'ete Americain*, Galerie Pierre Huber, Geneva, Switzerland

Collecting on the Cutting Edge, Laguna Gloria Art Museum, Austin, Texas

Redefining the Object, Wright State University Art Galleries, Dayton, Ohio

Almost White, Gabrielle Bryers Gallery, New York, New York

The Legacy of Surrealism in Contemporary Art, Ben Shahn Galleries at William Paterson University of New Jersey, Wayne, New Jersey

1989 *Real Inventions. Invented Functions*, Laurie Rubin Gallery, New York, New York

Works on Paper, Lennon/Weinberg Gallery, New York, New York

Democracy 4 China, Blum Helman Warehouse, New York, New York

New York, New York, Galeria 57, New York, New York

Dross to Art, Islip Art Museum, East Islip, New York

American Rainbow, La Galerie de Ponche, Paris, France

Lost and Found: The Object Transformed, Barbara Mathes Gallery, New York, New York

Socrates Sculpture Park, Long Island City, New York

Clockworks, MIT List Visual Arts Center, Cambridge, Massachusetts

Subverting the Grid, New Jersey Center for Visual Arts, Summit, New Jersey

Scatter, Shea & Becker Gallery, New York, New York

Microsculpture, Main Gallery, University of Rhode Island, Kingston, Rhode Island

Object of Thought, Anders Tornberg Gallery, Lund, Sweden

1990 *Transgressions: Donald Lipski and Buzz Spector*, The Corcoran Gallery of Art, Washington, DC

National Garden Festival, Gateshead, England

1991 *Whitney Biennial*, Whitney Museum of American Art, New York, New York

With Nature: Goldsworthy, Laib, Laudi, Lipski, Long, Mendieta, Newman, Galerie Lelong, New York, New York

Alchemy, Works by Three Sculptors: Suzanne Bocanegra, Ellen Driscoll, Donald Lipski, Fayerweather Gallery, University of Virginia, Charlottesville, Virginia

Art on Paper, Weatherspoon Gallery, University of North Carolina at Greensboro

Le Verre, International Exhibition of Contemporary Glass, Espace Duchamp-Villon, Rouen, France

1992 *Breakdown*, Rose Art Museum, Brandeis University, Waltham, Massachusetts

Assemblage, Southeastern Center for Contemporary Art, Winston-Salem, North Carolina

The Object is Bound, Stephen Wirtz Gallery, San Francisco, California

Transparence and Shape, Elga Wimmer Gallery, New York, New York

Cross Section, Outdoors and Indoors at Battery Park and the World Financial Center, New York, New York

The Nature of Science, Pratt Manhattan Gallery, New York, New York

A New American Flag, Max Protetch Gallery, New York, New York

Volumination: The Book as Art Object, Edwin A. Ulrich Museum of Art, Wichita State University, Wichita, Kansas

Eva & Adele, Christian Boltanski, Barbara Kruger, Donald Lipski, Allan McCollum, Bruce Nauman, Galleri Faurschou, Copenhagen, Denmark

1993 *Simply Made in America*, The Aldrich Museum of Contemporary Art, Ridgefield, Connecticut; traveled to The Contemporary Arts Center, Cincinnati, Ohio; The Butler Institute of American Art, Youngstown, Ohio; Palm Beach Community College Museum of Art, Lake Worth, Florida; Delaware Art Museum, Wilmington, Delaware

25 Years, Cleveland Center for Contemporary Art, Cleveland, Ohio

Annual Invitational Exhibition, American Academy and Institute of Arts and Letters, New York, New York

Collage and Assemblage, Lennon/Weinberg Gallery, New York, New York

1994 *Old Glory: The American Flag in Contemporary Art*, Cleveland Center for Contemporary Art, Cleveland, Ohio

Low Tech, Center for Research in Contemporary Art, University of Texas at Arlington, Texas

Points of Interest/Points of Departure, John Berggruen Gallery, San Francisco, California

Joe's Garage, TZ'ART & Co., New York, New York

1995 *Sculpture as Objects: 1915–1995,* Curt Marcus Gallery, New York, New York

1996 *Chimériques Polymeres,* Musée d'Art Moderne et d'Art Contemporain, Nice, France

The Northeast, The White House Sculpture Garden, Washington, DC

1997 *Embedded Metaphor,* organized by Independent Curators International (ICI), New York, New York; traveled to John and Marble Ringling Museum of Art, Sarasota, Florida; Western Gallery, Western Washington University, Bellingham, Washington; Contemporary Art Center of Virginia, Virginia Beach, Virginia; Bowdoin College Museum of Art, Brunswick, Maine; Ezra and Cecile Zilkha Gallery, Wesleyan University, Middletown, Connecticut; Pittsburgh Center for the Arts, Pittsburgh, Pennsylvania

Neuberger Museum of Art Biennial Exhibition of Public Art, State University of New York, Purchase Campus, New York

20/20: CAF Looks Forward and Back, Santa Barbara Contemporary Arts Forum, Santa Barbara, California

Recent Glass Sculpture: A Union of Ideas, Milwaukee Art Museum, Milwaukee, Wisconsin

No Small Feat: Investigations of the Shoe in Contemporary Art, Rhona Hoffman Gallery, Chicago, Illinois

Legible Forms, sponsored by International Sculpture Center, traveled to Hand Workshop, Richmond, Virginia; Chicago Public Library, Chicago, Illinois; Fullerton Museum Center, Fullerton, California; Sheldon Memorial Art Gallery, Lincoln, Nebraska

1999 *On the Ball: The Sphere in Contemporary Culture,* DeCordova Museum and Sculpture Park, Lincoln, Massachusetts

Drip, Blow, Burn: Forces of Nature in Contemporary Art, The Hudson River Museum, Yonkers, New York

Threshold: Invoking the Domestic in Contemporary Art, John Michael Kohler Arts Center, Sheboygan, Wisconsin

Twenty-six Sculptors and Their Environments, Rockland Center for the Arts, West Nyack, New York

SELECTED PUBLIC COLLECTIONS

Chase Manhattan Bank, New York, New York

The Art Museum of South West Texas, Midland, Texas

Brooklyn Museum of Art, New York, New York

The City of Denver, Denver, Colorado

The Corcoran Gallery of Art, Washington, DC

Dayton Art Institute, Dayton, Ohio

Denver Art Museum, Denver, Colorado

The Detroit Institute of Arts, Detroit, Michigan

Indianapolis Museum of Art, Indianapolis, Indiana

The Jewish Museum, New York, New York

Laumeier Sculpture Park, Saint Louis, Missouri

The Menil Collection, Houston, Texas

The Metropolitan Museum of Art, New York, New York

Miami Art Museum

The Minneapolis Institute of Arts, Minneapolis, Minnesota

Museum of Contemporary Art, Chicago, Illinois

Museum of Contemporary Art, Miami, Florida

Museum of Contemporary Art, San Diego, California

Museum of Fine Arts, Boston, Massachusetts

The Museum of Fine Arts, Houston, Texas

New Orleans Museum of Art, New Orleans, Louisiana

New York City Board of Education

The Panza Collection, Italy

Phoenix Art Museum, Phoenix, Arizona

The Progressive Corporation, Mayfield Heights, Ohio

The Verdin Company, Cincinnati, Ohio

Walker Art Center, Minneapolis, Minnesota

Frederick R. Weisman Art Museum, University of Minnesota

Whitney Museum of American Art, New York, New York

Selected Bibliography

BOOKS AND CATALOGUES

—— *Donald Lipski: Glass.* Brooklyn: Robert Lehman Gallery, 1991.

—— *Gathering Dust.* Cincinnati: University of Cincinnati, Tangeman Fine Arts Gallery.

—— *Hanging By a Thread.* New York: The Hudson River Museum, October 3, 1997–February 17, 1998, p. 14.

—— *New Art Selected by Phillis Freeman.* New York: Harry N. Abrams, Inc., 1990.

—— *Other Media.* Miami: Florida International University, 1980.

—— *Selections from the Collection of William J. Hokin.* Chicago: Museum of Contemporary Art, 1985.

——*Donald Lipski: Oral History.* Winston-Salem, North Carolina: Southeastern Center for Contemporary Art, 1994.

Abrams, Joyce. *Discarded.* West Nyack, New York: The Emerson Gallery, Rockland Center for the Arts. October 6–November 15, 1991.

Armstrong, Richard. *Biennial Exhibition.* New York: Whitney Museum of American Art, 1991, p. 154-57.

Arnason, H. H. *History of Modern Art,* fourth edition, Maria F. Prather, revising editor, New York: Harry N. Abrams, Inc., 1998.

Barrie, Dennis. *The Bells: Donald Lipski.* Cincinnati: The Contemporary Arts Center, 1991.

Benezra, Neal. *The Objects of Sculpture.* Chicago: The Arts Club of Chicago, 1988.

Boswell, Peter. "Profiles: Donald Lipski." In *Sculpture Inside Outside.* Minneapolis: Walker Art Center, 1988, p. 142-55.

Braathen, Barbara. *Gathering Dust.* The Hague, Netherlands: Germans Van Eck and P.B. van Voorst van Beest Gallery, 1984.

Cameron, Dan. *Redefining the Object.* Dayton, Ohio: University Art Galleries, Wright State University, 1988.

De Ak, Edit. "Donald Lipski." In *Seven Artists.* Purchase, New York: Neuberger Museum, State University of New York, College at Purchase, 1980.

Eaton, Timothy A. *Books as Art.* Boca Raton, Florida: Boca Raton Museum of Art, 1991.

Einreinhofer, Nancy. "Surrealism in America." In *The Legacy of Surrealism in Contemporary Art.* Wayne, New Jersey: Ben Shahn Galleries, William Patterson College, 1988.

Fillin-Yeh, Susan. *The Technological Muse.* Katonah, New York: Katonah Museum of Art, 1990-91.

Gumpert, Lynn. *The End of the World: Contemporary Visions of the Apocalypse.* New York: New Museum of Contemporary Art, 1984.

Holmes, Jon. *Twelve on 20 x 24.* Cambridge, Massachusetts: The New England Foundation for the Arts, 1984.

King, Elaine. "Donald Lipski" in *Artists Observed.* New York: Abrams, 1986, p. 38–39.

Kotik, Charlotta. *Working in Brooklyn/Sculpture.* Brooklyn: Brooklyn Museum of Art, 1985.

Kuspit, Donald. *Donald Lipski: Building Steam.* New York: Germans Van Eck Gallery, 1985.

Levin, Gail. *Forecasts: Visions of Technology in Contemporary Painting and Sculpture.* New York: Nerlino Gallery, Inc., 1988.

Levi-Strauss, David. *Donald Lipski.* Vienna: Bawag Foundation, 1999.

Morris, Barbara. *Off the Shelf.* Rockford, Illinois: Rockford College, 1990.

Neff, Eileen. *Donald Lipski: Who's Afraid of Red, White & Blue?* Glenside, Pennsylvania: Beaver College Art Gallery, 1990.

Rifkin, Ned. *Stay Tuned.* New York: New Museum of Contemporary Art, 1981.

Rubin, David S. *Donald Lipski: Poetic Sculpture.* Reading, Pennsylvania: Freedman Gallery, Albright College, 1990.

Ruffner, Ginny. *Glass: Material in the Service of Meaning.* Tacoma, Washington: Tacoma Art Museum, p. 36-37.

Salzillo, William. *Diamond, Lieberman, Lipski, Clinton.* New York: Edward W. Root Art Center, Hamilton College, 1980.

Stroud, Marion Boulton. *Donald Lipski: Who's Afraid of Red, White & Blue?* Philadelphia: The Fabric Workshop, 1991.

Timinski, Jan. *Piecemaker.* Newark: University of Delaware, 1985.

Van Wagner, Judith. "Interviewing Donald Lipski." In *Broken Wings: Donald Lipski at Grumman.* Brookville, New York: Hillwood Art Gallery, Long Island University, 1987, p. 7–18.

Welish, Marjorie. *Donald Lipski: Waxmusic and Candelabra-cadabra.* New York: Galerie Lelong, 1992.

Wylie, Elizabeth. *Donald Lipski: Recent Work.* Framingham, Massachusetts: Danforth Museum of Art, 1989.

Yau, John. *Awards in the Visual Arts 3.* Winston-Salem, North Carolina: Southeastern Center for Contemporary Art, 1984.

Yau, John. *Diverse Representation.* Morristown, New Jersey: Morris Museum, 1990, p. 30–31.

Yau, John. *Donald Lipski: Who's Afraid of Red, White & Blue?* Philadelphia: The Fabric Workshop, 1991.

Zaunschirm, Thomas. *Wolfgang Amadeus Mozart-Neue Bilder.* Salzburg, Austria: Galerie Thaddaeus Ropac, 1985.

ARTICLES AND REVIEWS

—— "Area Bells Ring Out to Salute CAC Show," *The Cincinnati Post,* November 14, 1991, p. 5C.

—— "The Hudson River Museum Hosts Donald Lipski: Poetic Sculpture." *Yorktown Edition,* April 3, 1991.

—— "Pony Up," *The Denver Post,* September 30, 1998, p. A1.

Artner, Alan G. "Donald Lipski," *Chicago Tribune,* October 2, 1986, Section 5, p. 9.

Atkins, Robert, "Civil (Dis)Service," *The Village Voice,* October 18, 1988, p. 87.

Bradford, Thomasine. "Interview: Lipski," *Art Papers: Contemporary Art in the Southeast,* November 1989, p. 2–7.

Bradley, Jeff. "New Public Sculpture Attracts Attention," *The Denver Post,* Friday, October 2, 1998, p. 7B.

Braff, Phyllis. "Not Only Patriotic, but Timely as Well," *The New York Times,* July 7, 1991, Section 12, p. 13.

Brenson, Michael. "A Sculptural Revival Around Town," *The New York Times,* November 1, 1985, Section C, p. 1, 22.

Brenson, Michael. "Donald Lipski, Matt Mullican, Kiki Smith," *The New York Times,* January 10, 1986, Section C, p. 22.

Brenson, Michael. "Donald Lipski," *The New York Times,* March 6, 1987, Section C, p. 83.

Brenson, Michael. "Coming to Grips with Contemporary Sculpture," *The New York Times,* June 19, 1988, p. 33.

Browne, Malcolm W. "Engines, Factories and Art, or the Machine as Muse," *The New York Times,* December 28, 1990, Section C, p. 1, 28.

Calas, Terrington, "Lipski at Loyola," *The New Orleans Art Review,* November/December 1991, p. 20–21.

Cantrill, Arthur and Corrine. "Mirror Replacements: An Interview with Donald Lipski," *Cantrilles Film Notes,* April 1975, p. 23–26.

Chadwick, Susan. "Sculpture Creates Something Unusual with Artistic Waters," *The Houston Post,* May 8, 1990, Section D, p. 2.

Chadwick, Susan. "Descendants of Duchamp on Display at Menil," *The Houston Post,* August 28, 1991, Section D, p. 1, 4.

Chadwick, Susan. "Texas-Found Objects Energize Assemblage Artist's Work," *The Houston Post,* April 26, 1993, p. B2.

Chandler, Mary Volez. "Horse Sculpture Comes to Library," *Rocky Mountain News,* September 29, 1998, p. 28A.

Cohen, Ronald. "Donald Lipski," *Artforum,* January 1984, p. 77.

Cornwell, Regina. "Martin Friedman," *Contemporanea,* p. 86–90.

Cotter, Holland. "Donald Lipski," *ARTnews,* October 1990, p. 184–85.

Cotter, Holland. "Donald Lipski," *The New York Times,* Friday, April 10, 1992, p. C32.

Cotter, Holland. "Messages Woven, Sewn Or Floating in the Air," *The New York Times,* January 9, 1998, p. E37.

Cullum, Jerry. "Sculpture Triumphs at Mannes Gallery," *The Atlantic Journal and Constitution,* October 25, 1990, Section D, p. 6.

DeLeon, Clark. "America: Back to the Future," *The Philadelphia Inquirer,* December 9, 1990, Section B, p. 2.

Drobojowska, Hunter. "Donald Lipski's Career in Sculpture Moves Full Steam Ahead," *Los Angeles Herald Examiner,* April 6, 1984, p. 32.

Findsen, Owen. "Bells Inspire this Sculptor to Sound Off," *The Cincinnati Enquirer,* November 10, 1991, Section K, p. 1, 4.

Frank, Peter. "Donald Lipski: Passing Time," *Art Express,* September/October 1981, p. 62–63.

Frank, Peter. "Art Pick of the Week," *Art Express,* September/October 1991, p. 62–63.

Gablick, Suzi. "Art Alarms: Visions of the End," *Art in America,* April 1984, p. 11–15.

Gamarekian, Barbara. "Angry Artists Cancel Shows at Corcoran," *The New York Times,* August 31, 1989, Section C, p. 19.

Gibson, Eric. "Two Sculptors," *New Criterion,* January 1986, p. 57–60.

Glueck, Grace. "Donald Lipski," *The New York Times,* September 20, 1985, Section C, p. 20.

Glueck, Grace. "A Chair, A Fireplace, Binoculars: Sculpture To Be Seen On the Street," *The New York Times,* January 16, 1998, p. E39.

Gouveia, Georgette. "Viewing Lipski Art is 'Time' Well Spent," *Gannet,* April 9, 1991, Section C.

Grantham, Kathy. "Katonah Museum's 'The Technological Muse,'" *North County News,* November 14–20, 1990, p. VI-3.

Haller, Romy. "Flag-Ball Controversy Sinks to New Low," *Pioneer of C.W. Post,* January 31, 1996, p. 3.

Hapgood, Susan. "Donald Lipski," *Flash Art,* December 1985/January 1986, p. 46.

Harrison, Helen. "Found Object in the Whimsical Spirit of Duchamp," *The New York Times,* April 5, 1987, Section C, p. 32.

Heartney, Eleanor. "Donald Lipski," *ARTnews,* November 1985, p. 145–47.

Hellman, Rick. "Lipski Turns Everyday Objects Into Challenging Artwork," *The Kansas City Jewish Chronicle*, April 23, 1993, p. 30A.

Hess, Elizabeth. "Upstairs, Downstairs, 1991 Whitney Biennial," *The Village Voice*, April 30, 1991, p. 93–94.

Hess, Elizabeth. "Capture the Flag," *The Village Voice*, February 20, 1996, p. 77.

Hixson, K. "Donald Lipski," *Arts Magazine*, September 1989, p. 106.

Iverem, Esther. "Art Is Where You Find It," *Newsday*, June 1, 1993, p. 51.

Jacobson, Aileen. "ARTS 2K," *Newsday*, November 9, 1999, p. B3, B13.

Johnson, Ken. "Donald Lipski," *The New York Times*, February 11, 2000, p. E37.

Johnson, Ken. "Donald Lipski," *The New York Times*, February 25, 2000, p. B40.

Johnson, Patricia C. "A Wave to Red, White, and Blue," *Houston Chronicle*, May 15, 1991, p. A10, D10.

Johnson, Patricia C. "Donald Lipski Senses Dark Edge of Texas," *Houston Chronicle*, April 27, 1993, p. 1D.

Johnson, Patricia C. "Somber Beauty," *Houston Chronicle*, April 27, 1993, p. D1.

Kangas, Matthew. "From Boeing Surplus to Rorschach Sculpture," *The Seattle Weekly*, May 6, 1987, p. 55.

Kasmin, Paul. "Donald Lipski," *Artforum*, Summer 1990, p. 164.

Kasmin, Paul. "Donald Lipski," *Artforum*, October 1990, p. 184.

Khewhok, Carol. "Donald Lipski: Poetic Sculpture," *Calendar News*, Honolulu Academy of Arts, March 1991, p. 3.

Kimmelman, Michael. "Donald Lipski," *The New York Times*, February 12, 1988, Section C, p. 20.

Kimmelman, Michael. "Donald Lipski," *The New York Times*, March 30, 1990, Section C, p. 25.

Kimmelman, Michael. "Donald Lipski," *The New York Times*, June 17, 1994, Section C, p. 21.

Klein, Mason. "Donald Lipski," *Artforum*, April 2000, p. 142.

Knight, Christopher. "Lipski's Poetry of Disorientation," *Los Angeles Times*, Friday, November 23, 1990, Section AF, p. 13.

Koslew, Francine. "Donald Lipski, Danforth Museum of Art," *Artforum*, November 1989, p. 155.

Kotz, Mary Lynn. "At the Whitehouse: The First Lady's Sculpture Garden," *Sculpture*, July/August p. 22–29.

Kowal, Jessica. "Veterans Say 'Flag Ball' is a Desecration," *Newsday*, December 19, 1995, p. A23.

Kwinter, Sandford. "Donald Lipski at Germans Van Eck," *Art in America*, January 1984, p. 126–27.

Larson, Kay. "Spring Cleaning," *New York Magazine*, March 30, 1980, p. 51.

Larson, Kay. "Small Wonders," *New York Magazine*, March 30, 1992, p. 62.

Leigh, Christian. "The 1991 Whitney Biennial," *Flash Art*, June 1991, p. 161.

Levin, Kim. "Review," *The Village Voice*, March 17, 1987, p. 72.

Lipson, Karen. "Time for Tea with the First Lady," *Newsday*, July 12, 1996, p. A12.

Litt, Steven. "Sculpture with Something to Say," *The Plain Dealer*, July 6, 1991, Section F, p. 6, 10.

Little, Carl. "Donald Lipski at The Parrish Art Museum," *Art in America*, November 1996, p. 122.

Littlefield, Kinney. "Donald Lipski," *Artweek*, January 17, 1991, p. 16.

Loughery, John. "Contemporary Assemblage," *Arts Magazine*, November 1987, p. 106.

Martin, Mary Abbe. "Walker's Sculpture Show Provocative, Grand in Scale," *Star Tribune*, May 27, 1988, Section E, p. 2.

McCoy, Mary. "Transgressions: Going Beyond the Apparent," *The Washington Post*, December 30, 1990, p. G9.

McCracken, David. "Two Sculptors Father Invention and Form," *Chicago Tribune*, September 23, 1988, p. 62.

McCracken, David. "Urban Junk Takes on Cross-Cultural Flair," *Chicago Tribune*, September 20, 1991, p. 62.

McEvilley, Thomas. "Donald Lipski," *Artforum*, December 1985, p. 66.

McGill, Douglas C. "Mining the Scrap Heap," *The New York Times*, January 24, 1986, Section C, p. 24.

McGuigan, Cathleen, Andrew Nagorski, and Maggie Malone. "Corcoran Showdown," *Newsweek*, October 9, 1989, p. 111.

Melrod, George. "Donald Lipski," *Atelier Magazine*, October 1992, p. 59–83.

Mifflin, Margot. "What Do Artists Dream?" *ARTnews*, October 1993, p. 144–49.

Milton, John. "Aeropagitica," *Art Issues*, November 1989, p. 13–17.

Muchnic, Suzanne. "The Norton Foundation Funds Adventurous Art," *Los Angeles Times*, April 15, 1991, Section B, p. 8.

Nesbit, Lois E. "Donald Lipski at Paul Kasmin and Lennon/ Weinberg," *Artforum*, Summer 1990, p. 164.

Norklun, Kathi. "Donald Lipski at Margo Leavin Gallery," *LA Weekly*, April 20, 1984, p. 46.

Orenstein, Alison. "He's Not Afraid to Wrap His Art in the Flag," *The Philadelphia Inquirer*, Sunday, November 11, 1990, Living Section, p. 30H.

Padon, Thomas. "Donald Lipski," *Sculpture*, July/August 1992, p. 66–67.

Perlberg, Deborah. "Donald Lipski," *Artforum*, April 1979, p. 67–69.

Porges, Maria. "Art of Glass: Looking Through History," *Sculpture Magazine*, January/February 1993, p. 42–47.

Porges, Maria. "Donald Lipski: Capp Street Project," *Artforum*, March 1994, p. 92–93.

Princenthal, Nancy. "Donald Lipski," *ARTnews*, December 1983, p. 161–62.

Princenthal, Nancy. "Reweaving Old Glory," *Art in America*, May 1991, p. 137–41.

Princenthal, Nancy. "Flag Sculpture Slashed," *Art in America*, March 1996, p. 27.

Rand, David. "Aesthetic Anarchy," Horizon, June 1988, p. 33.

Raynor, Vivien. "Juxtapositions Infused with Humor," *The New York Times*, May 12, 1991, p. 22.

Raynor, Vivien. "Two Exceptional Young Talents at the Neuberger," *The New York Times*, November 2, 1980, Section WC, p. 20.

Richard, Paul. "Artists Cancel Exhibitions at Corcoran," *The Washington Post*, August 30, 1989, p. A1.

Rogers, Pat. "A Grand Chandelier with Symbolic Roots," *Southampton Press*, October 21, 1999, p. B1, B5.

Ronck, Ronn. "Odds + Ends = Art," *The Honolulu Advertiser*, March 13, 1991, Section B, p. 1.

Saunders, Wade. "Talking Objects: Interviews with Ten Young Sculptors," *Art in America*, November 1985, p. 110–37.

Schwabsky, Barry. "Donald Lipski," *Arts Magazine*, November 1985, p. 140.

Schwabsky, Barry. "Donald Lipski's Book of Knowledge," *Artscribe International*, April/May 1986, p. 51–53.

Sloggat, Peter. "Time Capsules in Plain View," *Northport Journal*, November 18, 1999, p. 1, 13.

Smallwood, Lynn. "Expert on Inertness Juggles Junk," *Seattle Post Intelligencer*, May 7, 1987, Section D, p. 13.

Smith, Roberta. "Forays," *The Village Voice*, October 25, 1983, p. 92.

Smith, Roberta. "The Bells, Seven Rooms/Seven Shows," *The New York Times*, January 4, 1993, p. C18.

Smith, Roberta. "Donald Lipski," *The New York Times*, July 9, 1993, p. C26.

Sofer, Ken. "Donald Lipski," *ARTnews*, Summer 1987, p. 211.

Solin, Allison Lee. "Art: Past and Future," *The Independent*, February 20, 1997, p. 35.

Sorenson, Dina. "Donald Lipski," *Arts Magazine*, Summer 1990, p. 81.

Stein, Jerry. "The Bells," *The Post*, November 18, 1991, Section B, p 1–3.

Thornson, Alice. "Allure of Common Objects Fuels Unique Imagination," *The Kansas City Star*, May 23, 1993, p. J4.

Thomas, Walter. "Star Spangled Sculpture," *Interview*, November 1990, p. 22.

Van Proyen, Mark. "Objects Transformed Into Signifiers," *Artweek*, April 21, 1984, p. 4.

Visco, Stacianne K. "Flag Ball #3 Rolls into Post," *The Pioneer*, January 23, 1991, p. 19.

Willson, Judith. "Outside Chances," *The Village Voice*, July 8, 1981, p. 64.

Wintermute, Alan. "Donald Lipski at Germans Van Eck," *Flash Art*, Jaunary 1984, p. 37.

Woodward, Josef. "Up the Coast: Ventura County," *Los Angeles Times*, April 10, 1997, p. 44.

Wooster, Anne-Sargent. "Donald Lipski," *Art in America*, October 1981, p. 146–47.

Yood, James. "Donald Lipski," *Artforum*, December 1988, p. 128.

Zimmer, William. "Small Art," *Soho Weekly News*, December 7, 1978, p. 31–32.

Zimmer, William. "Art Pick," *Soho Weekly News*, November 8, 1979, p. 40.

Zimmer, William. "Big Names in the Recycling Game Coax Poetry from Debris," *The New York Times*, October 20, 1991, p. WC24.

Zimmer, William. "Industrial-Strength Sculpture with Economy-Size Politics," *The New York Times*, March 28, 1993, p. CN20.

Madison Art Center
Board of Trustees 2000–2001

Mary Ellyn Sensenbrenner, *President*
Robert M. Bolz, *Vice-President*
Roberta Gassman, *Vice-President*
Curt Hastings, *Vice-President*
William White, *Secretary*
Jeanne Myers, *Treasurer*
Marian Bolz, *Life Trustee*
Kitty Brussock, *Art League President*
Sonya Y.S. Clark
Daniel Erdman
Deirdre Garton
Terry L. Haller
Jay Handy
Brian Hendricks
Jesse Ishikawa, *Past President*
Cindy Kahn
Valerie A. Kazamias, *Chairperson,*
 Langer Society
Rob Long
Harvey Malofsky
William H. McClain
Joseph Melli
Linda Baldwin O'Hern
Teresa Pyle-Smith
Jan Schur
Diane Seder
Hathaway Terry, *Art Partners President*
Sylvia Vaccaro
David Walsh
Richard Zillman

Madison Art Center
Staff

Director's Office
Stephen Fleischman, *Director*
Jennifer Lin, *Assistant to the Director/*
 Publications Specialist

Administrative Department
Michael Paggie, *Business Manager*
Judy Schwickerath, *Accountant*
Christl Giese, *Receptionist*

Curatorial Department
Sara Krajewski, *Curator of Exhibitions*
Sheri Castelnuovo, *Curator of*
 Education
Marilyn Sohi, *Registrar*
Janet Laube, *Education Associate*
Jill Shaw, *Curatorial Assistant*
Karin Wolf, *Education Assistant*
Doug Fath, *Preparator*
Jessie Cork, *Photographer*

Development Department
Michael Grant, *Director of Public*
 Information
Susan Lang, *Director of Volunteer*
 Services
Nicole Allen, *Art Fair Coordinator*
Betty Merten, *Office Assistant*

Technical Services Department
Mark Verstegen, *Technical Services*
 Supervisor
Ali Beyer, *Technical Services Assistant*

Gallery Operations
James Kramer, *Gallery Operations*
 Manager
Craig Michaels, *Gallery Operations*
 Assistant
Stephanie Hawley, *Gallery Operations*
 Assistant
Amanda Ham, *Gallery Operations*
 Assistant
Stephanie Bifolco, *Security Guard*
Doug Cooper, *Security Guard*
Stacey Hegarty, *Security Guard*
Erica Hess, *Security Guard*
Ed Kreitzman, *Security Guard*
Laura Pescatore, *Security Guard*

Gallery Shop
Leslie Genszler, *Gallery Shop Manager*
Lori Snyder, *Gallery Shop Assistant*
 Manager
Cristy Buss, *Gallery Shop Assistant*
Molly Kelley, *Gallery Shop Assistant*
Stephanie Kliebenstein, *Gallery Shop*
 Assistant
Amanda Lee, *Gallery Shop Assistant*
Brooke Safranek, *Gallery Shop Assistant*
Shannon Schmidt, *Gallery Shop Assistant*
Nou Yang, *Gallery Shop Assistant*
Amanda Zdrale, *Gallery Shop Assistant*